UNSEEN
GRANTHAM

UNSEEN GRANTHAM

FRED LEADBETTER

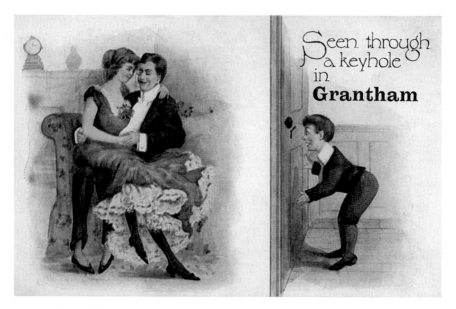

Seen through a keyhole in **Grantham**

I hope readers of this book will enjoy looking through the keyhole of time as much as this lad did spying on his elder sister and her young man. This type of card was printed blank and the name of the location added later.

First published 2014

The History Press
The Mill, Brimscombe Port
Stroud, Gloucestershire, GL5 2QG
www.thehistorypress.co.uk

British Library Cataloguing in Publication Data.
A catalogue record for this book is available from the British Library.

ISBN 978 0 7509 5911 7

Typesetting and origination by The History Press
Printed in Great Britain

CONTENTS

ACKNOWLEDGEMENTS

This publication would not have been possible without the help and support of many knowledgeable people who have volunteered information and advice wherever they could. It would be impossible to name them all, but thanks go to members of the Grantham Family History Society, especially Mr Richard Tuxworth, whose research into dates and family ties has been invaluable. I would also like to thank the staff at Grantham library, who are always helpful and attentive. Mr Robin Green has been instrumental with help on the last chapter regarding regimental history and identification of military badges, and has also contributed several of the images in the last chapter from his extensive military collection. Lastly I pay tribute to my wife Jenny, who has helped with my research, put up with my ill temper during times of slow progress, taken dictation from someone not used to giving it and has been instrumental in getting it all on the computer for the publishers to make sense of.

FOREWORD

W hen the author invited me to a preview of the images in his latest book, I was brimming with anticipation. Fred Leadbetter is a leading expert on postcards, photographs and ephemera of Grantham and he has already informed and entertained us with two previous volumes of archive images on the town. His knowledge is encyclopaedic and he has, in addition to publishing, displayed his erudition in many illustrated lectures using a modern version of the magic lantern!

When he told me that he had around 200 'unseen views' of Grantham, I was astounded – and he has not disappointed.

We owe an amazing debt to the postcard makers and photographers of the past and to all the collectors who have preserved them over the years. These images encapsulate the way we lived and the social history they reflect is immense. In addition to the pictures, we have, in many instances, a revealing snapshot of life in the messages written on the back of postcards. None is more evocative than the photographer's own message sent on a railway disaster postcard of 1906 (see page 25).

Each accompanying caption is succinct and belies the time the author has taken in meticulous research – through trade directories and other sources – of the information contained within each one.

This book can be enjoyed by natives as well as incomers (such as myself), because we can see the connection between the pictures of yesteryear and those of the town today. Much of the commercial life of Grantham has changed; but much still goes on – judge for yourself! Many of the names of now lost businesses are still remembered – Newcombe, Hornsby and Brittain. I was particularly excited to discover that the former Mayor of Grantham, Walter Plumb, lived in the house I now occupy (see page 38).

As we reach the 100th anniversary of the Great War, Grantham's part in it is fertile ground for research. One of Fred's sources is an album of letters, poetry and testaments to the hospitality of 'Little Mother' to soldiers far from home, often from the Colonies. This unique piece of social history is in stark contrast to the horrors of the battlefield. Fresh material relating to the Machine Gun Corps is also revealed in this book, and we are grateful to Fred for sharing it with us.

Fred Leadbetter has contributed much to the preservation and promotion of Grantham's local history. He has been the archivist to the Grantham Local History Society and in pursuing his passion for postcards, much of this book contains what must be unique pictures. In bringing all this material together, he has extended our knowledge of the town's history. He has generously shared his expertise with us and I, for one, am very grateful to him for this superb volume.

Stephen Vogt, 2014
Chairman of Grantham Local History Society

INTRODUCTION

This is the third compilation of photographs, postcards and ephemera that I have put together concerning the town of Grantham. Some of the ephemera dates from the 1700s, and the photographs of the town are from Victorian times. The postcard images begin in the early 1900s and continue through to the 1950s. Wherever possible I have acknowledged the early photographers who have made books like this one possible; unfortunately, not all of them stamped or signed their work. I have attempted to show images that most will not have seen before, but the more dedicated and informed reader will, however, note that there are one or two that have been previously published, either in my first two books or in other publications by like-minded individuals. This has been done to show continuity of the passage of time or to emphasise a point; I hope the reader will forgive this indiscretion and accept my excuses.

When selecting the chapter headings, I was in a quandary whether to arrange the book by theme, or – as with my other two books – by location. I decided on the latter, as I felt that by doing so, it would give a sense of continued progress through the book.

The reader will find within the pages of the book a wide range of subjects, with all aspects of everyday life in a bygone time. For all those individuals whose families have lived in the town for several generations, the book will show images of Grantham that their forbears would have seen as commonplace, but to the present Granthamian is a world lost forever by the relentless march of progress.

In the case of newcomers to the area, the images may help to explain why a particular gap in a building line exists or what was in a certain place 100 years ago, and in some cases, what building was in a particular position before the present one.

Whatever the reasons for picking up the book and opening its pages, I hope it gives the reader much enjoyment and pleasure. If I succeed in this endeavour, then I have accomplished what I set out to achieve.

Fred Leadbetter, 2014

1

NEW SOMERBY
AND SPITTLEGATE

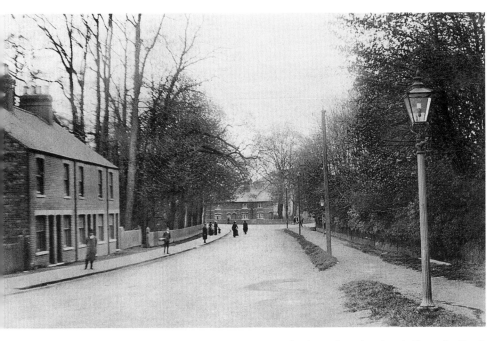

This postcard sent from the town in 1907 states on the front that the view is Somerby Road, Grantham. The publisher, who almost certainly was not local, probably means that it was the road to Somerby, as the correct location is Bridge End Road. Not a lot has changed on the left of the scene, but the wooded area on the right, leading to the turning for Harrowby Road, has now been developed.

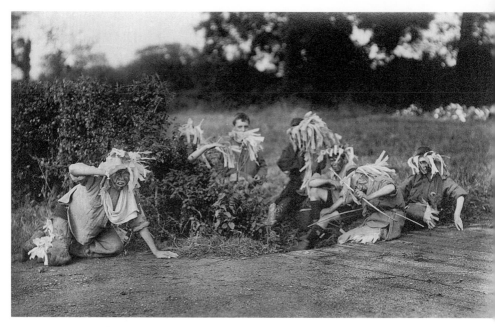

GRANTHAM.

On Tuefday the 26th of June, a Sweepftakes of 25gs each, by 4 yr olds; colts, 8ft. 7lb. fillies, 8ft. 4lb. one 4-mile heat.———(8 Subferibers.)

D. of Portland's Bay Bolton, by Match'em	1
Mr. Walfh's b. f. by Turk ———.	2
Mr. Douglas's br. f. Tetotum, by Match'em	3
Sir H. Harpur's ch. f. by Juniper ———	4

At ftarting, 6 to 4 agft Bay Bolton, and three to 1 agft Tetotum.

Same day, the Grantham Stakes of 50l. for all ages; 3 yr olds, 7ft. 9lb. 4 yr olds, 8ft. 7lb. 5 yr olds, 9ft 1lb. 6 yr olds, 9ft. 5lb. and aged, 9ft. 7lb.; mares allowed 3lb.—one 2-mile heat.

Capt. Bertie's br. c. John-a-Nokes, by Marfk, 4 yrs old ——— ———	1
Mr. Barlow's b. h. Mofes, 5 yrs old ——	2
Mr. Douglas's b. c. Moufe, 4 yrs old ——	3
Mr. Bowden's b. m. 5 yrs old ——	4
Mr. R. Willis's gr. c. Barbfon, 4 yrs old ——	5

Mofes the favourite.

Same day, the Hunters' Cup, value 150gs, by horfes, &c. that never won; 5 yr olds, 11ft. 6lb. 6 yr olds, 11ft. 12lb. and aged, 12ft. one 4-mile heat.

Ld

Above The hills and hollows have been put to many uses over the years, from visits by latter-day courting couples to modern-day mountain bikers. When this group of Boy Scouts paid a visit, it seems that they were dressed as Red Indians, no doubt to earn some relevant badge in woodcraft skills. The first Grantham Scout group was formed in 1909, nine years before this photograph was taken.

Left Back in the eighteenth century, Grantham had its own racecourse that could rival the best. In this race calendar for June 1781, it shares the pages with Ascot, Newcastle, Beverley and Hexham, to name but a few. The first recorded race appears in a calendar for 1727. The exact location of the course is unknown, but it is generally thought to have been somewhere on the high, flat ground between Harrowby and Somerby Hill.

Ponies Free from any distance.
1826.

Grantham Races

OVER THE NEW COURSE,
IN LEGGE FURLONG.

FIRST DAY, WEDNESDAY, JULY 26.

THE SYSTON PARK PLATE, value £50. for Ponies not exceeding 13 hands, Feather weight. The best of three heats; one mile. A previous winner of this plate not to be allowed to start.

THE GRANTHAM STAKES of Ten Sovereigns each, for Ponies not thorough-bred, nor exceeding 14 hands high. Three-years-old to carry 6st.; four-years-old, 7st. 7lb.; five-years-old, 8st. 3lb.; six-years-old, 8st. 11lb.; aged, 9st. The best of three heats; one mile and a half. Five Subscribers, or no race.

THE INNKEEPER'S CUP of £50. value, free for all Ponies not exceeding 13½ hands high. Three-years-old to carry 6st.; four-years-old, 7st. 7lb; five-years-old, 8st. 3lb.; six-years-old, 8st. 11lb.; aged, 9st. The best of three heats; one mile and a half.

A SWEEPSTAKES of Ten Guineas each, for three-years-old Ponies, not thorough-bred, nor exceeding 14 hands high. Colts to carry 8st. 5lb.; fillies 8st. 2lb. The best of three heats; one mile and a half. Five Subscribers, or no race.

SECOND DAY, THURSDAY, JULY 27.

THE FREEMEN'S PRIZE for Ponies not exceeding 12 hands high. Feather weight. The best of three heats; one mile.

THE HARROWBY STAKES of Fifteen Sovereigns each, with Ten Sovereigns added, free for all Ponies, not thorough-bred, nor exceeding 14 hands high. Three-years-old to carry 6st.; four years-old, 7st. 7lb.; five-years-old, 8st. 3lb.; six-years-old, 8st. 11lb.; aged, 9st. The best of three heats; one mile and a half. Three Subscribers, or no race. A previous winner of these Stakes not to be allowed to start.

THE GRANTHAM PLATE of Thirty Sovereigns, with a Subscription Purse of Twenty Sovereigns added, for Ponies not exceeding 13 hands. Feather weight. The best of three heats; one mile.

A FORCED HANDICAP of One Guinea each, for all the winning ponies, and any pony not exceeding 14 hands high to be allowed to enter on paying Two Guineas.

Entries to be made with Mr. Sardeson, at the Mail Hotel, or Mr. Goodacre, Black Dog, Grantham, with Mr. Stanwell, Hotel, Stamford, or Mr. Hurton, Globe Inn, Sleaford, on or before Saturday the 2nd. of July; after which double Entrance will be required.

All stakes to be made good before running; and disputes to be settled by the Steward.

The above Plates, &c. being to be raised by Subscription, such Gentlemen as are disposed to patronize the Races, are respectfully solicited to give in their Names, and state the amount of their Subscriptions, to Mr. Isaac Houghton, Auctioneer, Grantham.

STORR, PRINTER, VINE-STREET, GRANTHAM.

By 1826, this poster was advertising a July meeting over the 'new course'. Entries for the races could be taken in Grantham and as far afield as Sleaford and Stamford. It was a two-day event, but there were stipulations regarding some entries; if several of the races did not achieve a sufficient number of participants, then it appears as though those individual events would not be run. The last race meeting I can find was in the 1840s.

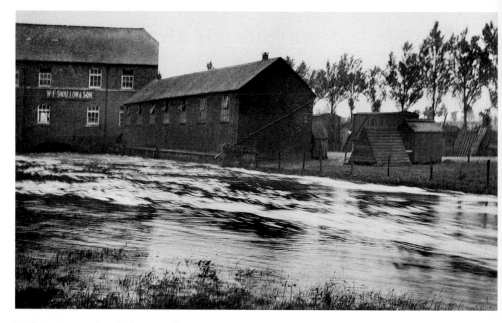

Fred Simpson, a local photographer, took this view of Swallows Mill on Bridge End Road in 1922, when the River Witham flooded and caused much havoc in the town. Although the Bridge End Road bridge escaped any damage, the next bridge – along in Witham Place – was swept aside by the torrent.

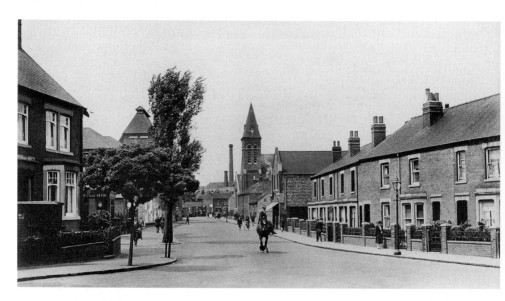

Sometime between the two world wars, this leisurely scene was captured on camera, looking north along Bridge End Road from the bottom of Houghton Road. The houses on the right and the old Co-op building on the corner of Inner Street show little change, but the small cottages and the Wesleyan chapel beyond were demolished in the mid-1960s. On the left behind the trees are the garage of Frank Launchbury and some billboards, behind which was the yard to the malting building, seen rising above the foliage.

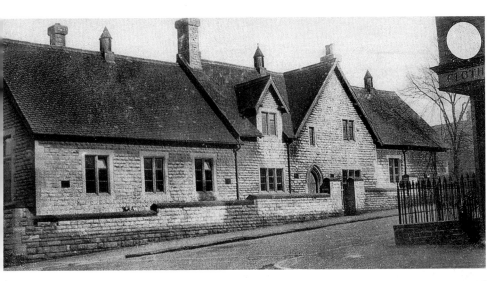

St Anne's school building, on the corner of Dudley Road and St Anne's Street, on a postcard dating from the late 1930s by an unknown photographer. The school closed in the 1970s, moving to new premises on nearby Harrowby Road. At the time of writing, the building is now used as a children's nursery. The shop on the extreme right of the view was Arthur Payne's drapers establishment.

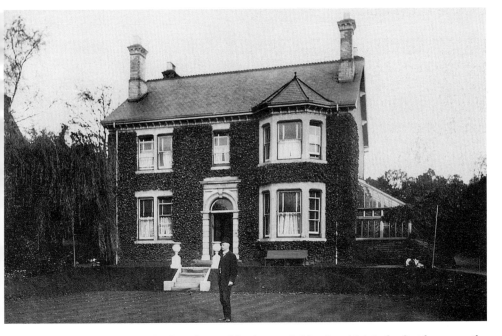

William Land stands on the front lawn of his house, Oaklands, which is the first house on the left as you enter Dudley Road from St Catherine's Road. Now No. 3, it sits next to Dudley House School, once the site of Dudley House itself. William was the managing director of local firm, the Grantham Crank and Iron Co., on Dysart Road. The postcard was sent by his stepdaughter, Gladys Bowden, in 1909 to friends in Exeter.

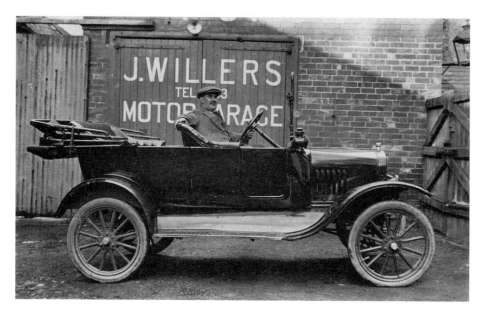

As the age of the motor car dawned in the first quarter of the twentieth century, there were many men who had the good business sense to take advantage of it. Motor garages, repair shops and taxi services: all were catered for in the Grantham area. This image shows James Willers outside his garage at No. 67 South Parade. James is listed in the 1926 Kelly's Directory as a motor car proprietor.

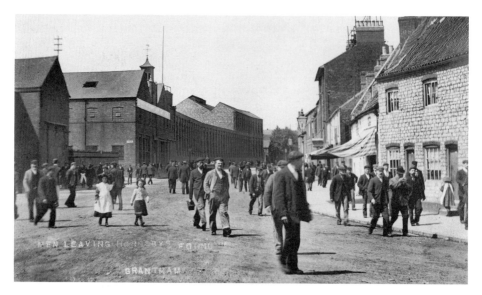

The caption on this card states 'Men leaving Hornsby's Foundry'. It gives a fine view of the Hornsby factory buildings on the west side of London Road, now replaced with a business park. On the left, just before Spring Gardens, is a building with two large wooden sliding doors, which were later replaced with ones of clear glass. The author can remember pressing his nose up against the glass doors as a young lad to gaze upon the firm's fire engine, which was kept here in the 1950s.

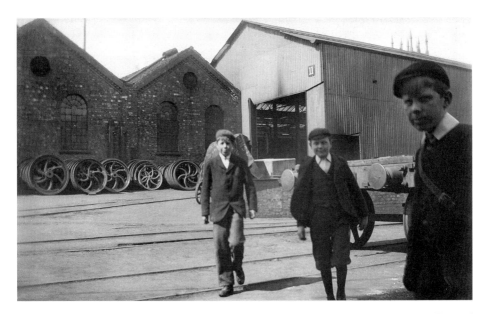

Richard Hornsby came to Grantham with his partner Seaman from the nearby village of Barrowby in the early 1800s. In 1828, Seaman left the business and it was Richard Hornsby that created the large industrial complex that many older Grantham people will remember. This photograph – taken around 1900 – shows three young chaps, probably apprentices, outside No. 11 shop. On the left can be seen a stock of flywheels used on the firm's portable oil engines.

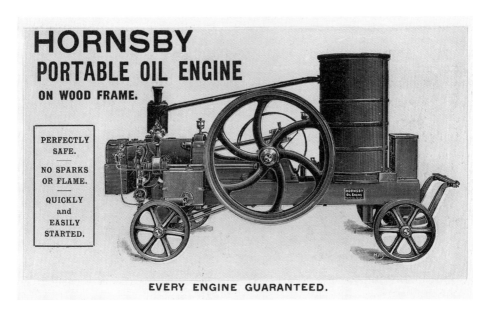

One of many cards produced for Richard Hornsby & Sons to advertise their products. It dates from the early 1900s and shows their portable oil engine. Note the remarks in the box on the left: 'no sparks or flame'. Farmers had to cope with many stackyard fires at this time, caused by sparks from traction engines used to drive their equipment.

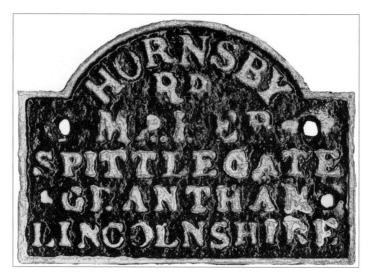

An early cast-metal plaque, which would have been fitted to one of Richard Hornsby's agricultural machines in the 1850s, before his sons joined the firm. It has corroded badly over the years, but the wording can still be understood:

Hornsby Rd (Richard)
Maker
Spittlegate
Grantham
Lincolnshire

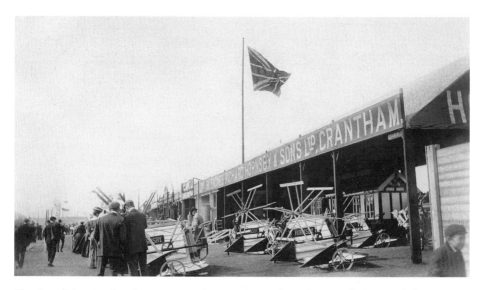

The firm did not only rely on paper advertisements; they also travelled around the country and abroad, showing off their products at agricultural shows and exhibitions. This is a postcard posted from Nottingham in 1907, showing their trade stand with many of the firm's equipment on display. It looks like a good crowd has turned out to see what's on offer.

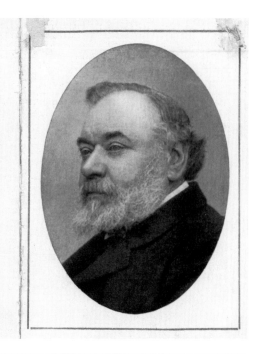

Above A memorial card for William Hornsby, who died in December 1907. His father, Richard, had been dead for many years, having passed away in 1864. William's brother – also named Richard – died in 1877, at the age of 50. With William's death and that of his other brother, James, in 1910, none were alive to see the firm amalgamate with the Lincoln Company of Ruston in 1918.

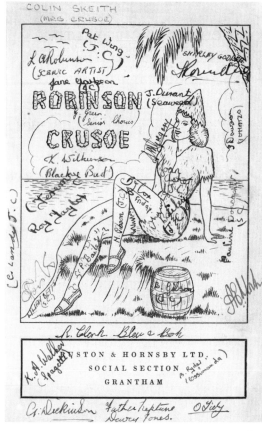

Right Large firms like Ruston & Hornsby did their best to ensure that the social life of their employees was catered for; if this also helped to entertain the general public, then so much the better. The company's Christmas pantomime was looked forward to by many local residents. This is a programme for the 1954 offering, which was *Robinson Crusoe*. Most of the cast have signed the front cover; including Roy Taylor, whose stage name became Vince Eager when he turned professional.

RUSTON & HORNSBY

GRANTHAM
SOCIAL SECTION

— PRESENTS —

ITS
ELEVENTH
ANNUAL
PANTOMIME

ROBINSON CRUSOE

In the
**CORONATION
HALL**
STATION ROAD

with

QUEENIE INGRAM	ETHEL RICHARDSON	COLIN SKEITH
AS "ROBINSON"	AS "POLLY"	AS "MRS. CRUSOE"

and

GROVE DICKINSON	SILVIA CROWSON	KEITH WILKINSON
PETER FOISTER	JOY WILKINSON	KEITH WALKER
ROY TAYLOR	JOSE DURRANT	HAROLD WOODS
BARRIE COX	BETTY RYDER	IVAN DAWSON
ROY CLARK		PETER SMITH

also
CORPS DE BALLET & THE TINY TAPPERS

Commencing **SATURDAY, JAN. 30th, 1954,** until **SATURDAY, FEB. 6th,** at 7.30 p.m. Each Evening, with Matinees on both Saturdays at 3 p.m.

Prices of Admission:—3/6, 2/6 & 2/-

CHILDREN HALF PRICE for the nights of Jan. 30th, Feb. 1st and 2nd and both Matinees

Seats may be booked at Ruston & Hornsby's Main Offices, London Road, on and after January 18th, 1954
Box Office Opens 9.30 a.m.

PALMERS PRINTING & PUBLISHING CO. LTD., 4, VINE STREET, GRANTHAM

A poster for the *Robinson Crusoe* pantomime, their eleventh annual production. The pantomimes were always held up Station Road in Coronation Hall, formerly the works canteen. Performances usually ran for one week with matinees on the two Saturdays.

Right A *carte de visite* of St Johns church, Spittlegate, dating from the early 1880s. The church, designed by Salvin in the early English Lancet style, was built in 1840–41. The photographer, Joseph Priest, was one of the town's earliest and had studios at No. 1 London Road.

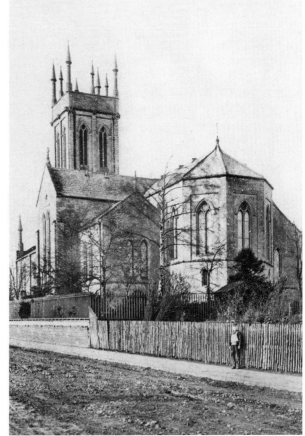

Below A later postcard view of the church, dating from the early 1900s, after the building had undergone extensive alterations in 1884. Over on the right, the malting buildings on Nursery Path can just be seen through the trees.

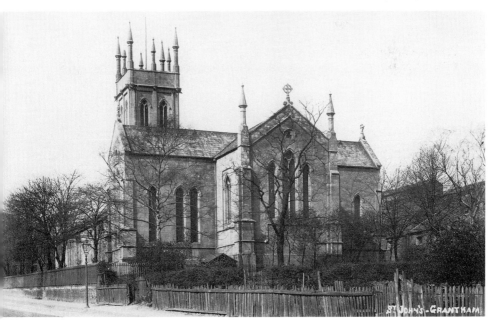

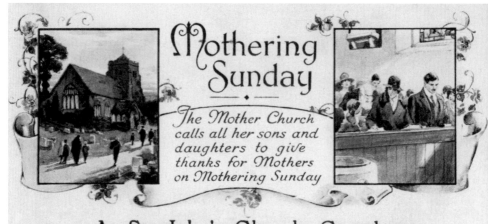

Mothering Sunday

The Mother Church calls all her sons and daughters to give thanks for Mothers on Mothering Sunday

At St. John's Church, Grantham

A MOTHERING SERVICE WILL BE HELD ON MARCH 11TH AT 6.30 P.M.

In olden days the 4th Sunday in Lent was kept as Mothering Sunday. Grown-up Children all came home to visit Mother. The whole family went to Church, Mother to thank God for her Children, Father and Children to thank God for all that Mother had been to them. Will you help us to revive this beautiful old custom in our Parish, remembering the old saying: "Those who go amothering find violets in the lane—" violets of undying love?

"BE SUCH ANOTHER AS CHRIST TO HIS MOTHER."

An interesting little card, dating from the 1930s. It calls on the congregation of the church to help revive the custom of Mothering Sunday. Children of today must think that it has never been out of fashion, but obviously it took the age of commercialism and the help of our American cousins to really bring it back into the fold.

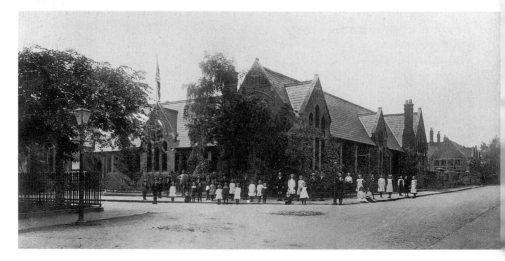

This picture by local photographer Alfred Emery was taken from the top of Commercial Road, with Launder Terrace on the right. Alfred has identified the card as St John's school, and this is the name in all the directories of the time. There had been a school in Spittlegate since 1844, but these buildings which catered for both girls and boys were erected in the 1880s. Further accommodation for infants was built soon after. The card was sent to Runcorn by the senior assistant at the school, George Hawbrook, in 1914. The school closed in 1976.

2

CANAL AND
WHARF ROAD AREA

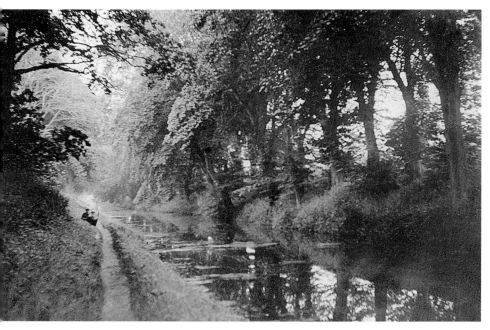

A stretch of the Grantham–Nottingham canal between Grantham and Harlaxton. The card was posted from Grantham in 1907. The canal was opened in the late 1790s, but by 1929, the London and North Eastern Railway – who now owned the waterway – closed it to traffic and it was officially closed in 1936.

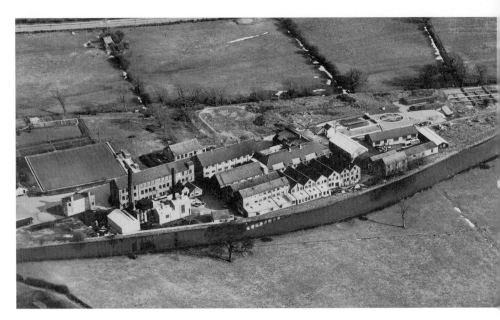

An image of Bjorlows tannery dating from the late 1930s, with only open fields between the factory and Harlaxton Road (at the top of the image). The firm had taken over the premises previously occupied by Shaws, who had been on the site alongside the canal since 1863.

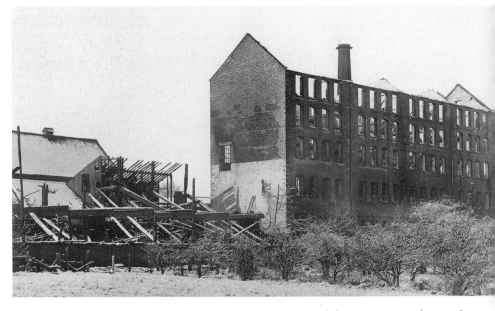

A fire at Alexander and John Shaw's tannery in 1915 caused damage costing thousands of pounds. This would not have helped the company's fortunes, which were already under pressure after a previous fire in April the same year. By the time firemen arrived on the site, it was already too late to save much of the building.

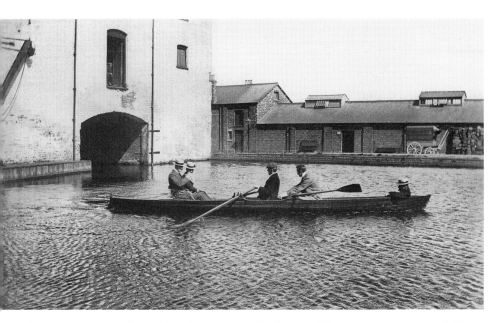

Five gentlemen go for a leisurely boat ride in the canal basin sometime around 1900. They probably hired the boat from the building on the left. This was the old granary, where in the past, barges would pass through the arch to load or unload their wares. The building was demolished in 1929.

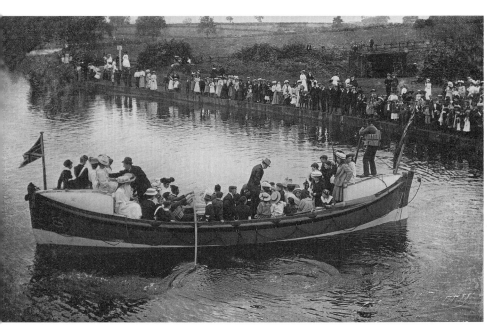

In 1906, the Skegness lifeboat came to the town on a fundraising drive. After parading around St Peter's Hill, it proceeded along Wharf Road to the canal basin, where it was launched with great ceremony. The lifeboat crew then rowed onlookers around the basin for the princely sum of 1d each.

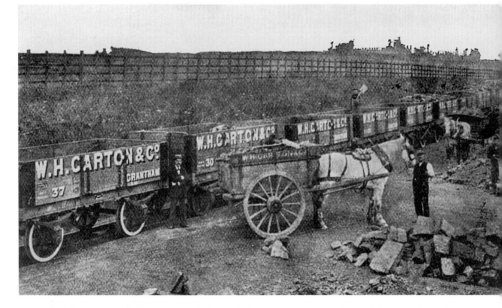

Local coal merchants of any size would have their own railway trucks to pick up their coal from the Nottingham coalfields. W.H. Garton's merchants' trucks are seen here in the sidings of the old Ambergate line up on the old wharf around 1910. They would then have their own horse-drawn transport pick up the coal and deliver it to their customers in the town and local villages.

W.H. Garton's offices were opposite the top of Guildhall Street at No. 21 High Street. The company was an old Grantham firm, having been established in 1837. The building is listed in the local directories of 1900 as 'The Bank House', and looking at the imposing frontage, it's no surprise for what use the property was originally intended.

The Grantham train crash of 1906 has been well covered by several excellent publications, but this postcard has a little more local significance than most other images. It was taken by local photographer Fred Simpson and sent by him to relatives in Lincoln. Fred states in the message on the back that he got several good snapshots of the terrible scene and has been busy printing them for sale. He signed the card 'Fred S'.

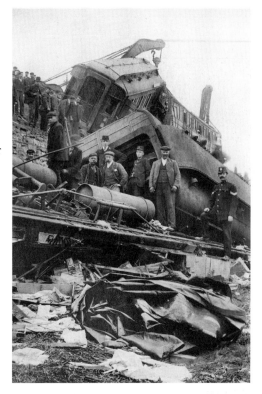

At the end of July 1932, the town was blessed with 18cm of rain in three days, resulting in the worst local floods since 1922. The Mowbeck watercourse was unable to cope with the amount of water and this caused flooding in Alexander Road, the bottom of Dysart Road and Wharf Road to name but a few. Always the opportunist, Fred Simpson took the next two photographs from a window above his studio at No. 17 Wharf Road.

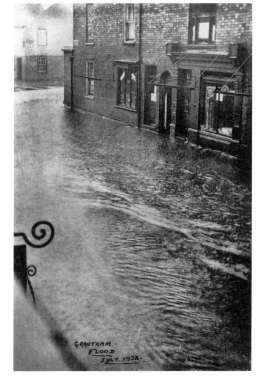

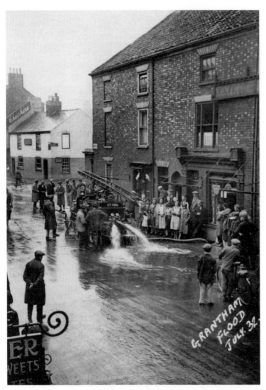

The floods filled the cellars of many properties and here Fred has captured the Grantham fire brigade pumping out the basement of Charles Wesley Dixon's house-furnishing store. To the left of the image can be seen the Durham Ox public house on the corner of Welby Street. Until the redevelopment in the 1980s, this street joined Wide Westgate to Wharf Road.

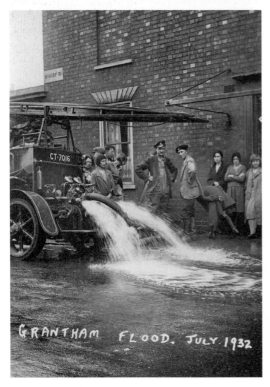

Once Fred was confident of not getting his feet wet, he came down from his upstairs window and took more shots of the fire brigade doing their work. They have moved along a shop and are now working on the cellars of Arthur Charity's boot repairers at No. 66. Arthur had only recently moved from Welby Street, an action he might at this time be regretting. The two firemen seen with their hands on their hips are named on the back, left to right, as Jack Twilley and 'Cockney' Fenemore.

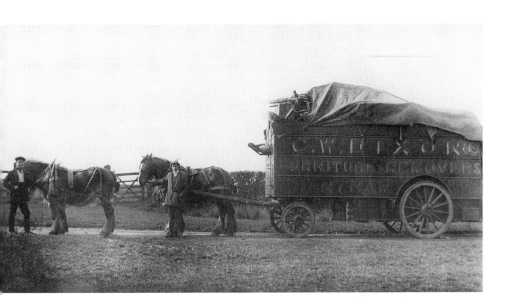

Above Charles Dixon's removal transport, on a postcard dating from around 1910. The business had been on Wharf Road from the second half of the 1800s. It is hoped that the unseen furniture on this particular load is stacked a little more carefully than that on view at the front of the transport.

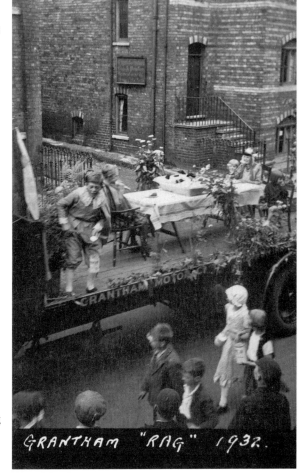

GRANTHAM "RAG" 1932.

Right Grantham Rag Week was held each year to raise funds for the town's hospital. This is a photograph from the 1932 parade and shows the Grantham Motor Company float just passing Wharf Road Hall. It is uncertain what the subject is but it looks like some sort of royal feast.

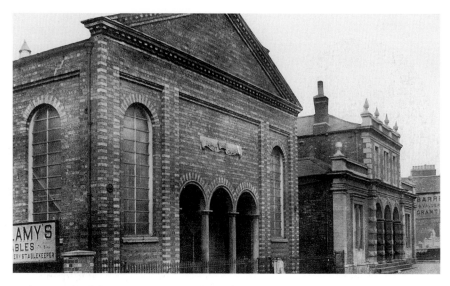

A photograph of the Baptist chapel on Wharf Road, around 1910, by local stationers the Needham brothers. It was the first purpose-built place of worship for the Baptists, who had previously held their services in the Exchange Hall on the High Street. In the late 1850s, the congregation split after differences of opinion arose and it was this breakaway group that built the chapel on Wharf Road in 1863. Sadly, the building was condemned in the early 1920s. The slipper baths to the right of the chapel were demolished in the early 1980s as part of the Wharf Road redevelopment scheme.

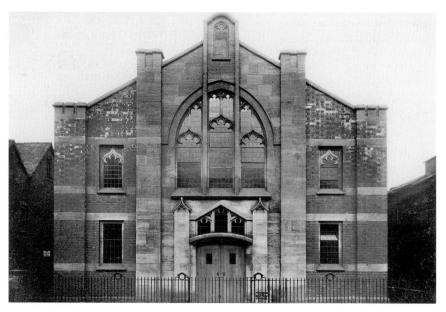

The Baptist church we see there today was built on the site of the old chapel and opened on 6 March 1930, shortly before this photograph was taken. The building is one of the rare survivors of the redevelopment previously mentioned that took place on the north side of Wharf Road in the 1980s.

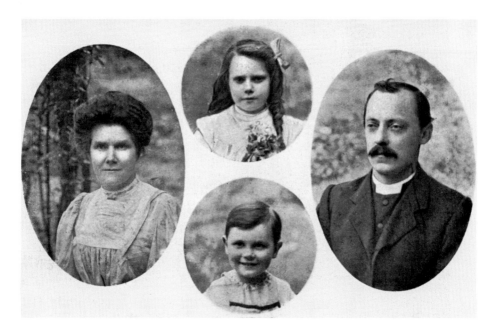

Above It was quite common to issue a postcard showing the new minister or chaplain of a particular church or chapel. This one is of Thomas Minchin with his wife, Amelia, and their children, Hilda and Leslie. He was the minister for the Baptist church on Wharf Road between 1910 and 1913.

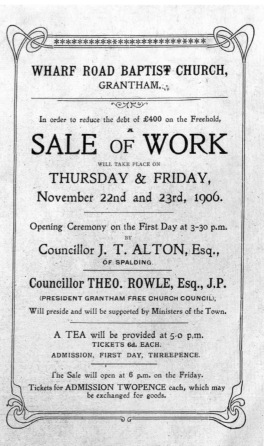

WHARF ROAD BAPTIST CHURCH,
GRANTHAM.

In order to reduce the debt of £400 on the Freehold,

SALE of WORK

WILL TAKE PLACE ON

THURSDAY & FRIDAY,
November 22nd and 23rd, 1906.

Opening Ceremony on the First Day at 3-30 p.m.

BY

Councillor J. T. ALTON, Esq.,
OF SPALDING.

Councillor THEO. ROWLE, Esq., J.P.
(PRESIDENT GRANTHAM FREE CHURCH COUNCIL),

Will preside and will be supported by Ministers of the Town.

A TEA will be provided at 5-0 p.m.
TICKETS 6d. EACH.
ADMISSION, FIRST DAY, THREEPENCE.

The Sale will open at 6 p.m. on the Friday.

Tickets for ADMISSION TWOPENCE each, which may be exchanged for goods.

Right In 1906, the congregation of the church held a 'Sale of Work' to help reduce the debt of £400 on the freehold. There were fancy goods on sale and a stall selling home-grown fruit and veg. You could also check your weight for 1*d*, and if you felt really daring, you could get an electric shock from a battery before leaving the hall.

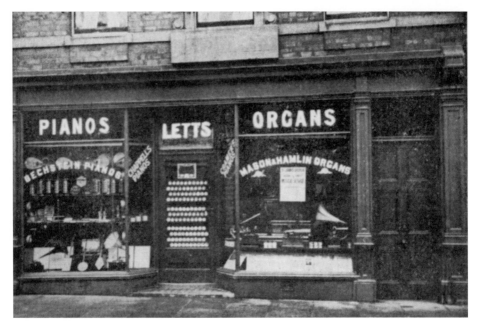

John Letts' shop was at No. 3 Wharf Road. He established his business in 1867 on North Parade, but moved to these premises in 1889. He was a talented musician in his own right, being the organist at Stoke Rochford church in the early 1900s. John was also the booking agent for the Theatre Royal at this time.

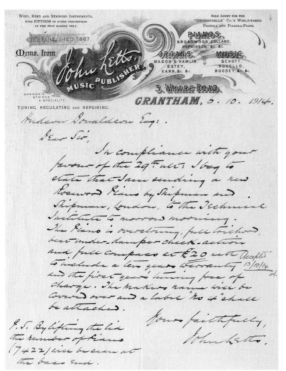

John called his shop 'The Grantham Pianoforte and Organ Depot', and this billhead appeared on a letter to Hudson Donaldson Esq., Director and Secretary for Education for Kesteven, informing him that he would have a rosewood piano delivered the next day by Shipman & Shipman of London to the Grantham Technical Institute. The institute was in buildings adjoining the Guildhall on St Peter's Hill.

3

ST PETER'S HILL AREA

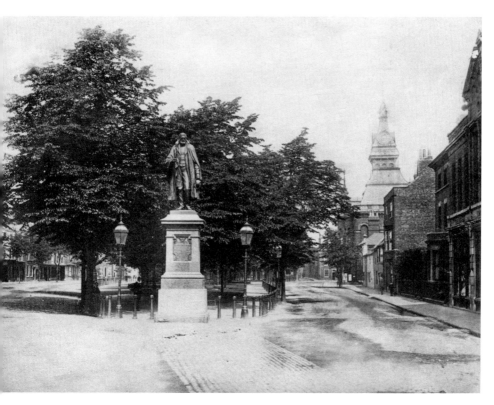

A very quiet-looking St Peter's Hill one early morning in 1897. The statue of Frederick Tollemache looks down on the thoroughfare, much as he has done ever since his likeness was placed there in 1892. Tollemache had been one of the main players on the town's political scene for a good part of the nineteenth century. He was the town's Liberal MP, on and off, from the 1820s to the mid-1870s.

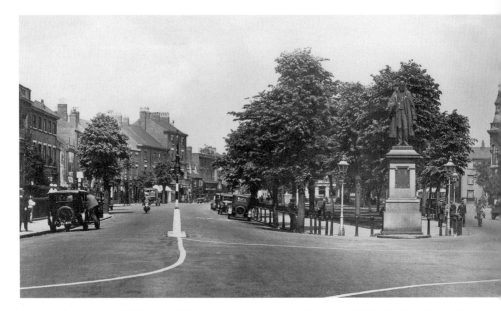

A much later view of St Peter's Hill on a postcard sent to Ilford in 1933. By the 1930s, this part of town was a very different place from when Frederick Tollemache's statue was erected. The road is now marked with white lines to aid the flow of traffic but it looks as though the council still needs to get a grip on the parking situation. There were still several trees dotted along the edge of the road but by now their days were numbered.

Surely this cannot be the earliest view of the taxi rank over the road from the Guildhall, all patiently waiting for the shoppers from the nearby supermarket carrying bags of groceries, looking for a ride home. That scenario was still more than fifty years in the future when this postcard was posted in 1929.

Right A late 1920s postcard of the Guildhall and library, soon after the latter was opened in May 1926. Like so many other towns, Grantham was helped with funding the building of the library by the Carnegie Trust. At the time of writing, the building houses the town's museum, with the library now located above the shopping centre across the road.

Below A printed postcard of St Peter's Hill Green, published by Arthur Sidney Jones of Nos 19 and 20 Wharf Road, sometime in the mid-1920s. The photographer has stood at the entrance of Elmer Street South and taken this image of an oft-photographed area from an unusual aspect. Most photographs of this part of town include the Guildhall and the statue of Sir Isaac Newton.

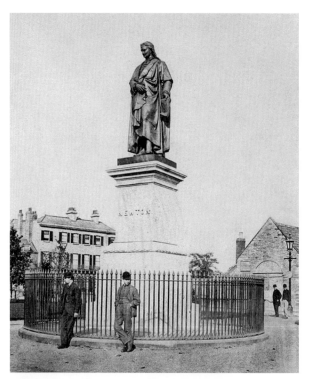

Speaking of which, here is the man himself. Taken much earlier, this image dates to about 1868, before the Congregational church was built in 1869, but after Cheney House was demolished in 1867. Newton's statue was inaugurated in October 1858, ten years before the new Guildhall was created.

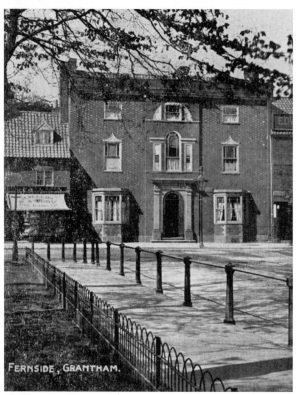

FERNSIDE, GRANTHAM.

Fernside School was a private educational establishment for young ladies, run by a Miss Margaret Hancock. The building was originally a private eighteenth-century house, but had been a private school run by the Hancock family since the mid-1800s. This postcard was published around 1910, when the school's time was nearly at an end. It became a soup kitchen during the First World War, and in the early 1920s, became the home of John Hall furnishers. At the time of writing, it is the home of Lloyds bank.

It was a tradition of the school for the pupils to put on an annual concert, with the proceeds going to various worthy causes. These included gifts to the needy and on this occasion the St Wulfram's organ fund. Originally the concerts took place within the school building itself, but in later years – such as this one in 1904 – the Theatre Royal in George Street was blessed with their presence.

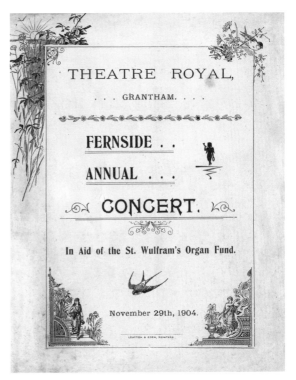

When Queen Victoria died in January 1901, the whole country entered into a state of mourning. Grantham played its part in this national show of sorrow, and this floral arrangement on an ornate wrought-iron frame complete with the town's heraldic emblem was hung over the main entrance to the Guildhall.

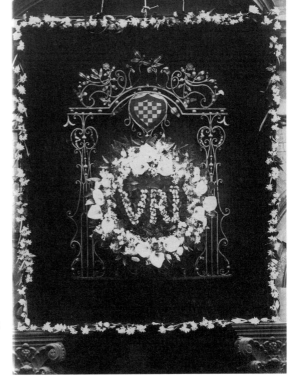

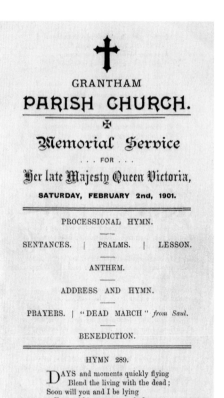

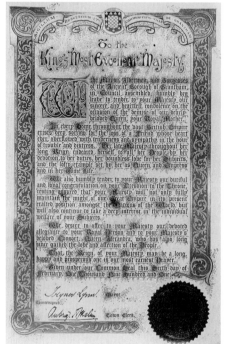

A copy of the memorial service for the late queen that was held at the parish church on 2 February 1901. The ceremony was attended by all the local dignitaries, including the town council. I am not sure what the mayor had been up to, but there is a footnote at the bottom of the back page which notes that 'the congregation are requested to keep their places until the Mayor has passed out'.

A copy of an elaborate letter that was sent to the new King Edward VII by 'The Mayor, Aldermen and burgesses of the ancient borough of Grantham'. In it, the gentlemen express their deep regret on the loss of the king's mother, while at the same time congratulating him on his accession to the throne. The diplomatically worded manuscript is signed by the mayor, Tryner Lynn, and countersigned by the town clerk, Aubrey Malim.

Right There was confusion surrounding the celebrations for the coronation of King Edward VII. As can be seen, this programme was issued for the festivities to take place on 26 and 27 June 1902. Unfortunately the king was suddenly taken ill and the actual coronation was postponed until August.

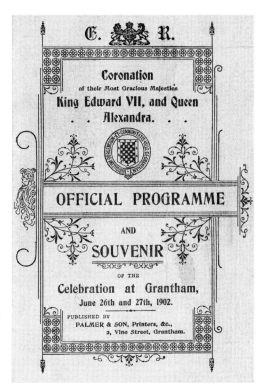

Below Nowhere was better decorated than St Peter's Hill for the coronation celebrations. There were Chinese lanterns in profusion and many of the gas lamps had images of the king and his queen, Alexandra, placed around the glass covers. One of the king can be seen at the top of the lamp in this image, just to the right of the man standing in the foreground.

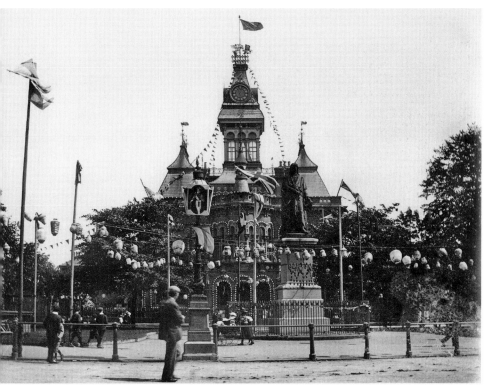

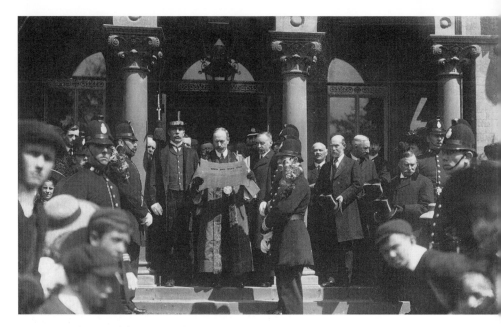

As Edward came to the throne late in life, he only reigned for a short time. In May 1910 the Mayor of Grantham, Walter Plumb, read the proclamation for the king's son George V from the Guildhall steps. The whole process was then repeated at the obelisk in the Market Place.

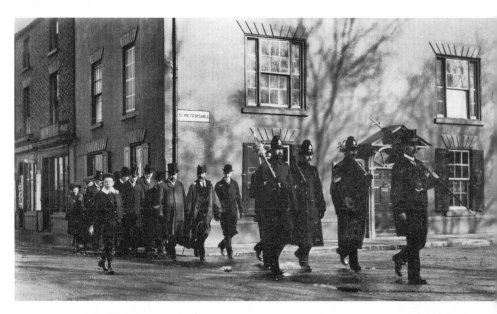

The mayor for 1908/1909 was Robert Barley King. Here we see him returning to the Guildhall after the ceremony of 'Churching the Mayor' in 1908. The group are just passing No. 1 St Peter's Hill on the corner of the High Street. This was the home of Theodore Norton, a prominent Grantham solicitor. The property was demolished in the early 1920s to make way for the Lloyds bank building we see there today. Lloyds have since moved over the road, but the property is still used as a bank.

In 1937 the country celebrated another coronation, that of King George VI. The Guildhall was illuminated after dark and this unknown photographer has captured the spectacle in all its glory. The railings round Newton's statue were soon to disappear, taken like so much other fine metalwork in the town when the Second World War began.

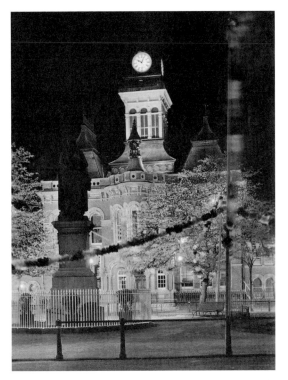

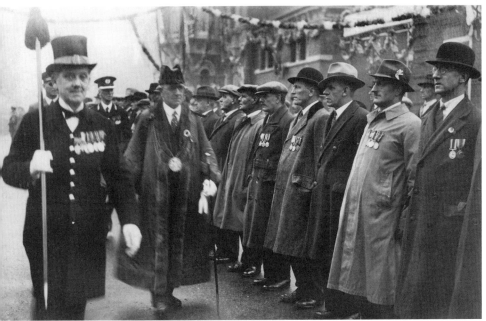

The mayor during the coronation year was Arthur Eatch, and here we see him inspecting veterans from the First World War outside the Guildhall as part of the celebrations. The photograph was taken by our old friend Fred Simpson, who at this time still operated from his studio at No. 17 Wharf Road.

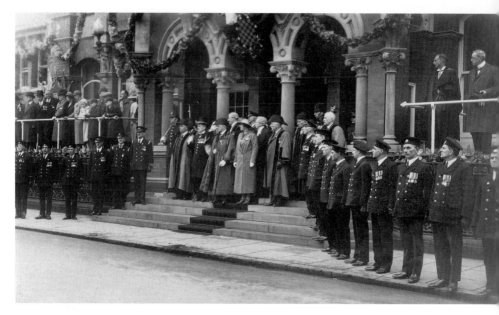

The mayor takes the salute, standing on the Guildhall steps. Although there is no evidence of it in these two postcards, the majority of the celebrations that followed were spoilt by bad weather, with the rain lasting almost throughout the day. It had only been two years since the country had celebrated the silver jubilee of George V, but Grantham folk's enthusiasm for a good time could still be counted on and many turned out despite the bad weather.

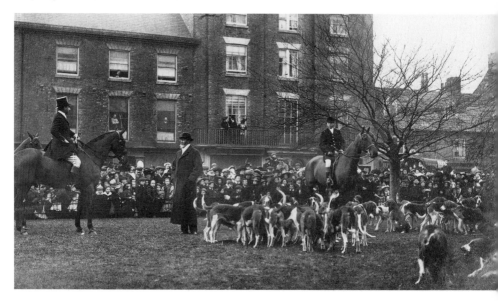

The Belvoir hounds have met at St Peter's Hill on Boxing Day for many years and 26 December 1910 was no exception. In this year they were greeted by Lord Brownlow, the tall gentleman in the trilby hat and thick white scarf seen left of centre of the image. The building in the background with the balcony was at this time the premises of John Hopkinson, house decorator, but by 1916 it was the home of the Picture House, Grantham's first purpose-built cinema.

The Picture House opened for business during the First World War, in February 1916. It was built from designs by Albert Winstanley of Blackpool and could seat 1,000 people. The price for admission was either 3d, 6d or 1s and pictures were shown daily from 6.30 p.m. to 10.30 p.m.

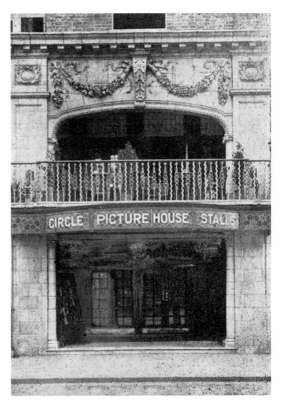

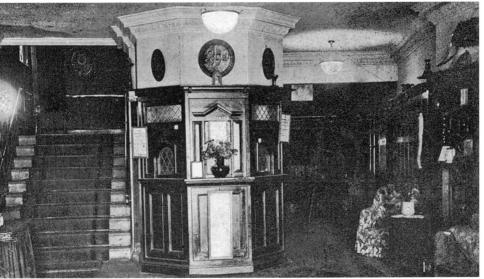

A photograph showing the entrance hall of the cinema with the ticket office in a central position. The ground-floor rooms were to the right, with upstairs facilities to the left. The building catered for much more than individuals wanting to see the latest films; if required, a gentleman or lady could have their hair attended to or spend their leisure in the various luncheon and tea rooms.

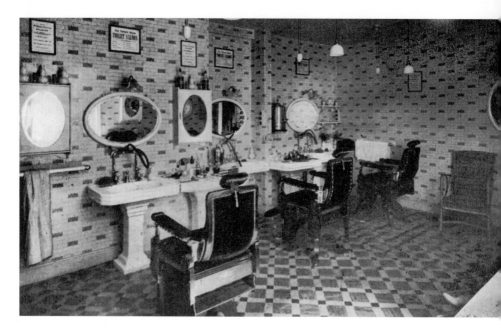

A view of the gentlemen's hairdressing saloon, fitted out with all the latest appliances. There was also an electric massage available for anyone brave enough to try out this new technology. Throughout the week there were separate baths available for both sexes, although Sundays were reserved for gentlemen only.

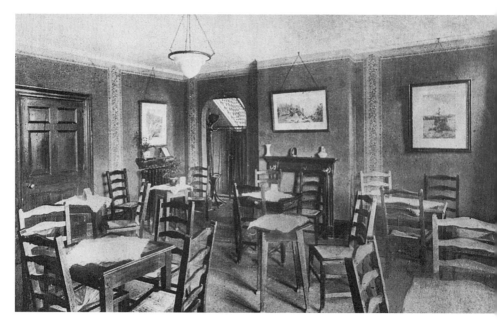

There was plenty of room for individuals who wished to wine and dine. The premises included tea rooms, dining rooms and this luncheon room on the second floor. The Picture House succumbed to the march of progress in the early 1960s, when the building was demolished to make way for a Tesco supermarket.

4

ST CATHERINE'S ROAD AND CASTLEGATE AREA

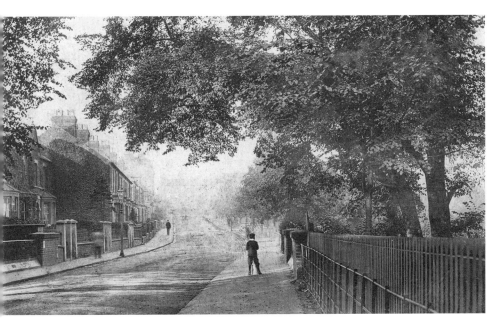

In 1905, an unknown photographer stood on the bridge crossing the River Witham on St Catherine's Road to capture this image looking towards the St Peter's Hill and London Road junction. On the left of the scene, just over the bridge, is Augers Terrace. This row of fine townhouses has a date stone of 1874 in the brickwork.

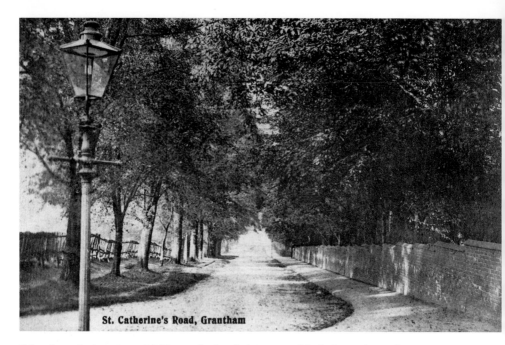

St. Catherine's Road, Grantham

Taken from the junction with Harrowby Road, this scene of St Catherine's Road captures a very rural view on a postcard in 1907. The left of the card shows no residential property at all, and on the right is the brick wall enclosing the house and gardens of Stonebridge House.

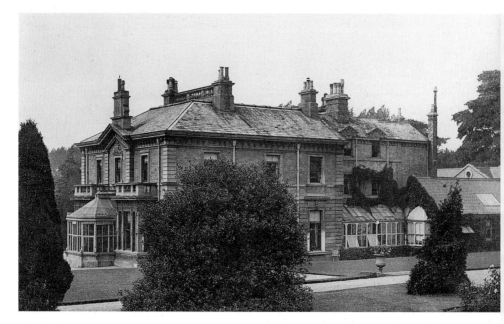

Stonebridge House was built in 1858 for John Hardy, one of the town's Victorian bankers. It later became Spittlegate Boys' School and, in 1959, Grantham police station. At the time of writing, the house is unoccupied. The card showing a view of the rear of the property was posted by one of the servants to Haxby, Yorkshire, in 1909.

Right It was popular in Edwardian times for householders great and small to have a photograph taken of their property to send to friends and relatives. Grove End House at No. 28 Avenue Road, pictured here, was the home of Mrs William Thompson, but the card was actually sent by the daughter of Mrs Thompson's cook. The majority of the houses on this side of Avenue Road are now offices or other business premises.

Below When John Campbell opened the Picture House on St Peter's Hill in 1916, he was already the sole proprietor of the Theatre Royal and Empire in George Street. Like his other business venture, the Theatre Royal catered for the creature comforts of his clientele, serving lunches, teas and all kinds of beverage as well as quenching their thirst for thespian delights.

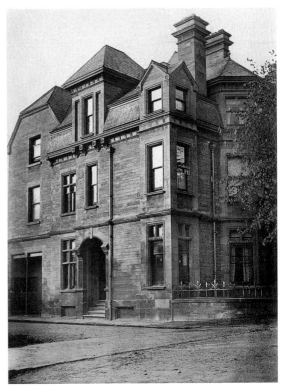

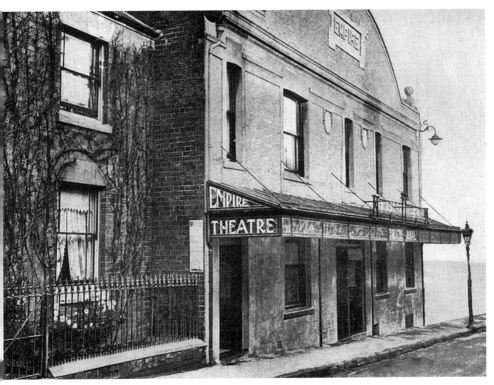

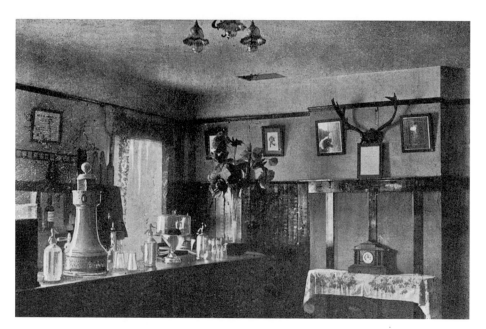

One of the well-equipped bars where customers could relax in between performances. There was even an officers' lounge to cater for the commissioned men training at the army camps close to the town. This was fitted out with the best upholstered seating, genuine oak beams and a fine panelled fireplace in one corner.

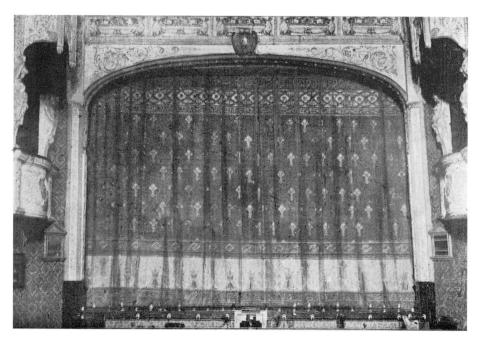

The theatre itself had been recently fitted out with new stalls and décor surrounding the stage. There were two boxes either side, which could be had for the price of 21s each, a staggering amount of money at the time. If you were a little more frugal, you could sit in the stalls for 6d.

This box office plan of the theatre gave the customer an idea of the layout, so that when booking their seats, they would have a choice of location. There was a warning, however, displayed near the booking office, which read, 'Seats booked by telephone are not kept after the rise of the curtain'. In other words, do not be late.

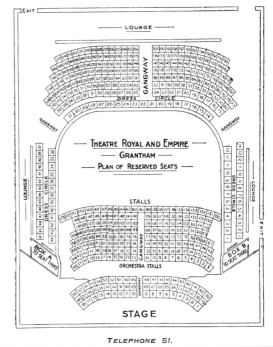

A photograph of John Campbell and his wife Mary. John was a man of many talents, being an author, actor and playwright, penning many plays for his wife to play the leading role. Mary was a popular actress in her own right, going under the stage name Mary Fulton.

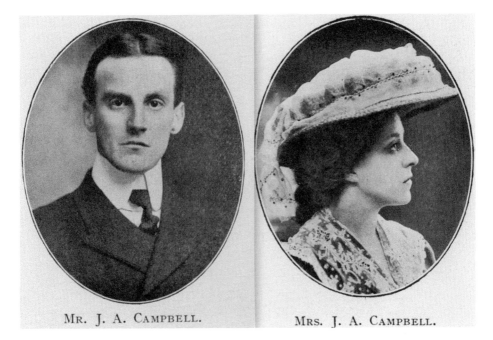

MR. J. A. CAMPBELL. MRS. J. A. CAMPBELL.

Left The Edwardian photographers knew that having a group of children in their images would always help to sell their postcards. That must certainly be true of this charming study of six small children outside the Beehive public house in Castlegate, even if some of them have got their backs to the camera. Over the road can be seen the fruit shop of Charles Lockton and the premises of butcher T.B. Cooper.

Below On 13 April 1905, the YMCA opened their new Grantham branch in Middlemore House, Castlegate. This postcard shows William Hornsby performing the opening ceremony, which looks to be well attended. The association did not stay very long at this address, moving to the old Kings Picture Palace building on Wharf Road in 1918, then moving again to premises in the Market Place.

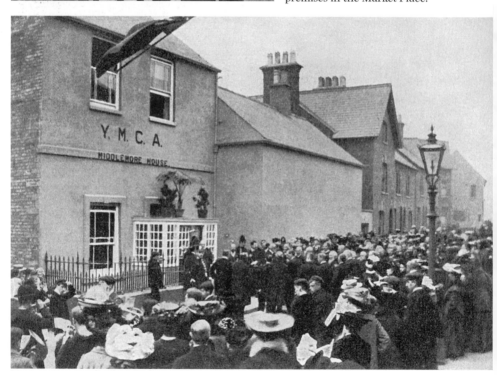

5

WESTGATE AND
THE MARKET PLACE

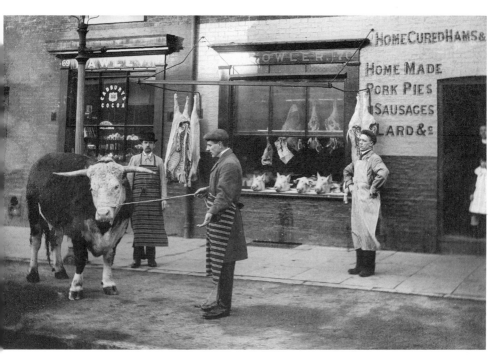

Joseph Fowler's shop was located at No. 70 Westgate; it was one of many butchers in the town when this photograph was taken in the 1890s. The image has obviously been staged for advertising purposes. The open window displaying Joseph's wares gives a good indication of health and safety requirements in Victorian Grantham; the row of pigs' heads look as if they are about to burst into song. The shop is still a butchers today, being the premises of Watkins, who also own the premises next door, occupied in this image by Hawley's sweet shop.

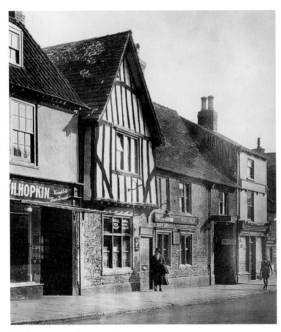

The Malt Shovels was one of Grantham's oldest public houses, its name relating to the malting industry that was once a key feature in the town. This postcard dates from the early 1930s and shows a partial view of Herbert Hopkins' furniture store next door on the left, with William Richardson's grocers shop on the right. The pub closed in 1960, but the building is still going strong as one of the town's many restaurants.

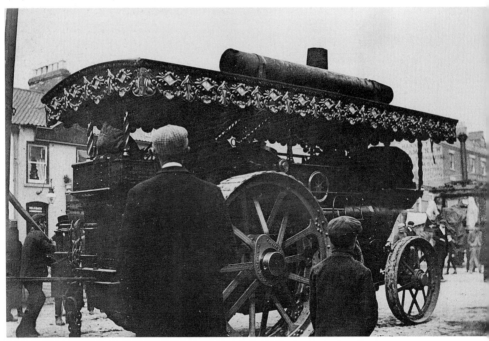

The Mid Lent Fair has been coming to Grantham since the reign of Richard III (1483–85). Over the years, many locals seemed to gain as much pleasure from watching the fair people erect the amusements on the Sunday as they did visiting the entertainment over the next three days; after all, the Sunday entertainment was free. This image dates from the late 1890s, and shows a fair traction engine moving into position close to Atlas House (No. 77 Westgate), at this time the home of Hannett, Kelham & New, cabinet makers and upholsterers.

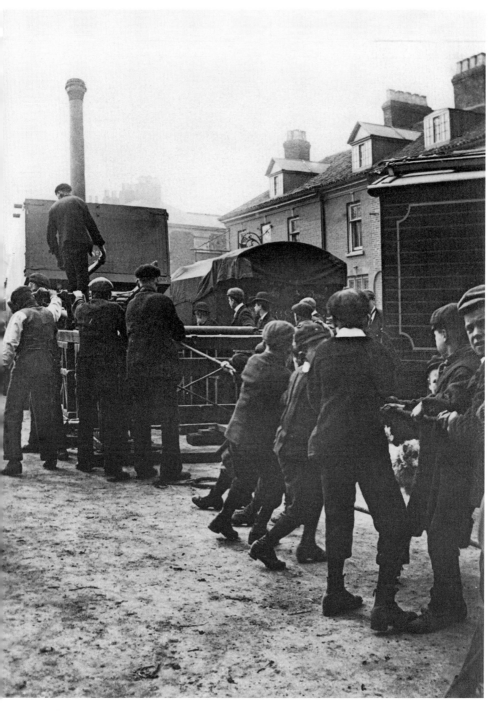

The photographer has now moved further towards Narrow Westgate, turned and taken this image of men erecting the fairground equipment. This time they have co-opted the help of a group of young lads to heave on the ropes. To the left of centre can just be seen the top of the sign for the Blue Bull Hotel on the corner of Dysart road.

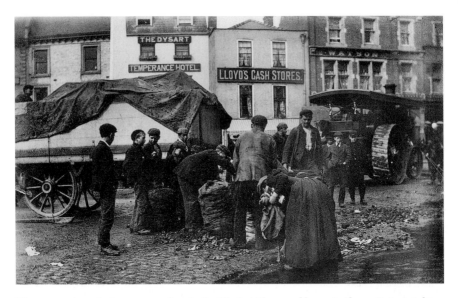

The cameraman has now moved on to the Market Place and here similar activity is taking place. The fair people are moving sacks of coal, which would be needed in quantity to fuel the various equipment, which at this time would be mostly driven by steam. Behind the wagon to the left of the photograph can be seen the obelisk, which replaced the old Market Cross in the mid-1880s.

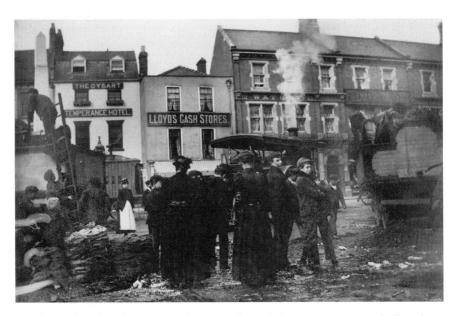

Another view taken from much the same place. A few more young onlookers have appeared on the scene and it looks as though the traction engine is on the move. In the background to the right of the Dysart Temperance Hotel is Lloyd's cash stores, a newcomer to the Market Place, taking over Broughton's tea house in 1898. The building was demolished a few years after this image was taken and replaced by the property we see there today, with a date of 1904 above the top windows.

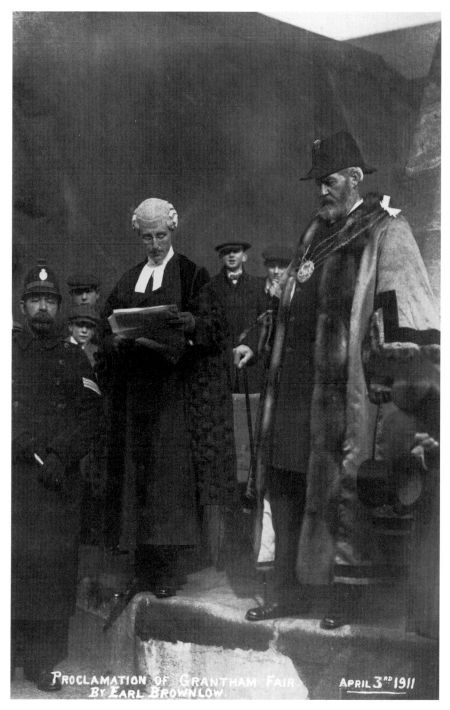

PROCLAMATION OF GRANTHAM FAIR.
BY EARL BROWNLOW.

APRIL 3RD 1911

Lord Brownlow was Mayor of Grantham in 1911 and can be seen here carrying out the age-old tradition of opening the fair from the Market Cross steps. He was in fact the first mayor to do so in over twenty-five years as the cross had only been returned to its rightful place in January of that year, after giving way to the obelisk erected in 1886.

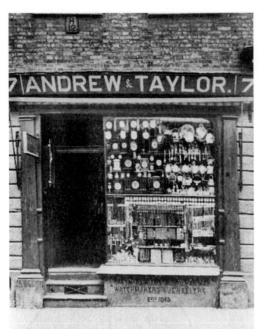

Andrew & Taylor's Silversmiths, Watchmakers and Jewellers' shop was located at No. 7 Westgate, close to the Market Place. Charles Andrew established the business in 1845 but when this photograph was taken in around 1910, his nephew, William Taylor, had been running the shop for ten years.

ESTABLISHED 1845.

7, Westgate, Grantham, September 19 1931.

Miss Senescall, Woolsthorpe,

Dr. to TAYLOR & SON,

WATCH AND CLOCK MAKERS, SILVERSMITHS AND JEWELLERS.

—— REPAIRS NEATLY EXECUTED. ——

Ladies Wrist Watch on expanding band	9. 0.
Paid same date, pp. Taylor & Son. With Thanks	

One of William Taylor's receipts, dated September 1931. It shows that by this time he had dropped the name of his uncle from his billheads; it also shows that his son has entered the firm, having learned the trade under his father's guidance.

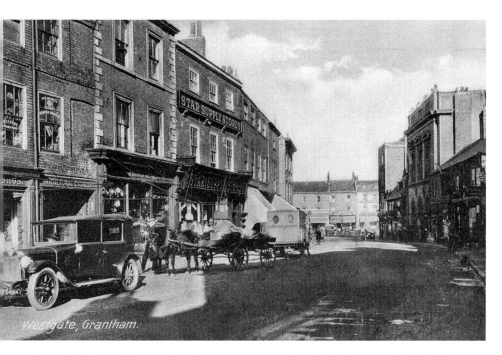

A scene in Narrow Westgate from the interwar years. Star Supply Stores on the left of the image was one of two shops run by the company in the town at this time, the other being on St Peter's Hill. The large sign over the shop window is now long gone, but the stone brackets supporting the firm's name are still in position.

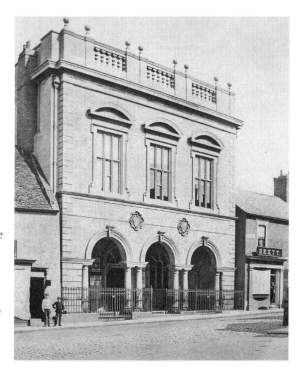

Westgate Hall was built in 1852, approximately twenty-five years before this photograph was produced. One of the town's two corn exchanges it was the last building in the Market Place before entering Narrow Westgate. To the left of the hall at this time was tailor George Upton's premises at No. 31 Market Place, while to the right sat No. 1 Westgate, the home of Sexty's jewellers. The Sexty brothers also had a shop on the High Street.

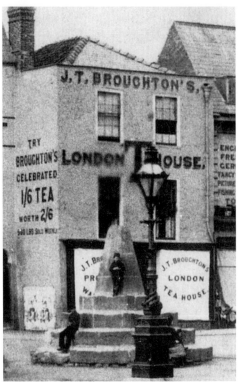

A view of Broughton's 'T' house in 1884/85. The Market Cross was removed in 1885 and, as can be seen, work is already afoot in this image. An advert on the side of the building asks the public to try the company's celebrated tea at 1s 6d, which they claim is actually worth 2s 6d; clearly the age of retail psychology had arrived.

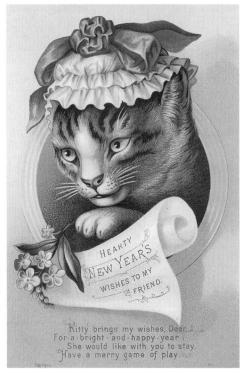

Towards the end of the Victorian era, scraps were very popular and a particular favourite of young girls, who collected the pieces of paper and stuck them in albums, forming unique collections much prized by collectors today. They came in many guises, but many were in the form of greetings cards, such as this New Year card given away by Broughton's to their customers.

The company had their advert printed on the back of the card which, when given to the child or teenager, would end up stuck to the album page, never to see the light of day again. Fortunately for collectors such as myself, they would sometimes escape this fate and finish up in modern-day albums so both sides could be viewed by interested parties.

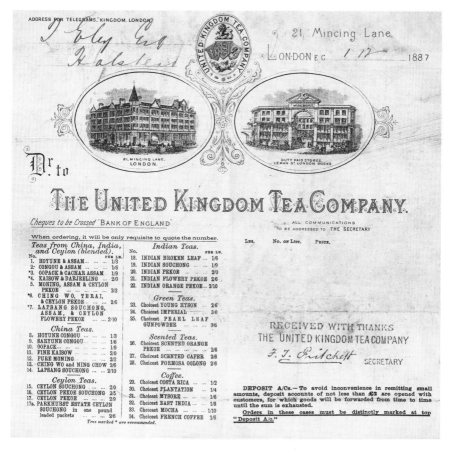

Today we tend to take the drinking of tea for granted but even as late as the 1880s, it would be priced out of the reach of many households. Broughton's would probably buy their product from a wholesaler, such as this one, who sent their price list out in 1887. The United Kingdom Tea Company's brand of teas certainly had imaginative names, especially No. 25, 'Pearl Leaf Gunpowder': probably blended to blow your head off.

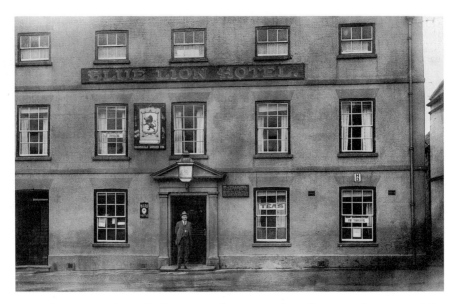

If you fancied something a little stronger than a cup of tea, there was always one of the five establishments selling stronger stuff in the Market Place, who would welcome the opportunity to satisfy your thirst. Although a sign in the window of the Blue Lion Hotel advertises teas, there are also adverts for Bass in the bottle on the wall near the door and in another window a poster advertising local brewery Mowbray's strong ale. This postcard from the first decade of the 1900s shows the proprietor George William Benson proudly standing on the doorstep of his business premises.

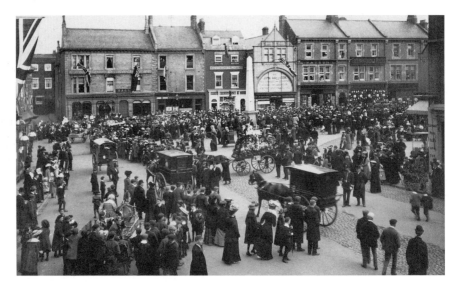

At first glance this looks to be rather a sombre occasion, but it is in fact an early morning in 1906, when the crowds are gathering for the tradesmen's turnout. Soon the Market Place will be bustling with carts and wagons belonging to the local businesses, but as yet, very few have arrived. To the right of the obelisk is the building erected in 1904 that replaced Broughton's premises mentioned earlier.

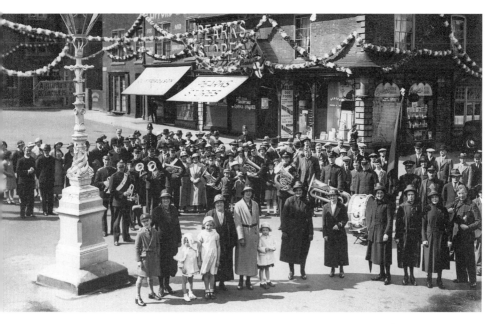

The Salvation Army band gathers in the Market Place during the celebrations commemorating the centenary of the corporation in 1935. Not all of the names are known, but on the back of the card is written the following information: 'Man with drum, Fred Selby. Lady right of drum Mrs Coldron. Second right from lamp post Mr Coldron and another Gentleman named as Les Roberts.'

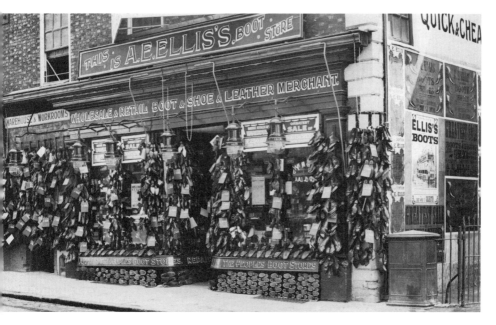

Arthur Ellis was originally the manager for Freeman, Hardy & Willis, whose boot and shoe shop was at No. 13 Market Place, but by 1909 Arthur had opened up shop on his own just over the road at No. 17. This photograph must have been taken for advertising purposes just after the shop opened, as it would have taken Arthur's staff some time to have set up this display.

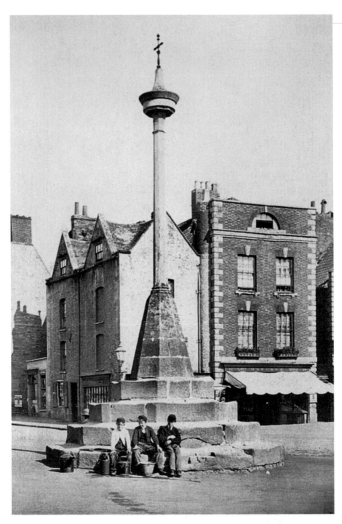

Joseph Priest issued this *carte de visite* at the beginning of the 1880s. It shows the Market Cross some years before it was replaced by the obelisk, with three young lads resting on its steps after collecting water from the nearby conduit. The building behind and to the left of the cross was at this time the general post office. The shop on the right was the business premises of Joseph Hancock, grocer and provision dealer. Joseph was also the town's postmaster.

Right The conduit was erected in
1597, when fresh water was brought
to Grantham from springs near
Barrowby, thereby being the first public
water supply in the town. Over the
years there have been several repairs
carried out to the structure, but
only two inscriptions note the dates
when this was done; on one occasion
in 1793 and again in 1927, when
Richard Brittain was mayor. The young
chap in the photograph has just filled
his water carrier, very similar to the
ones shown in the last image.

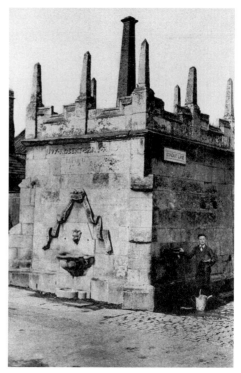

Below An early engraving of the
conduit by local printer Lawrence
Ridge. Lawrence took over his father's
printing business at the corner of High
Street and Finkin Street in the 1860s,
and produced this image, dating from
the 1870s.

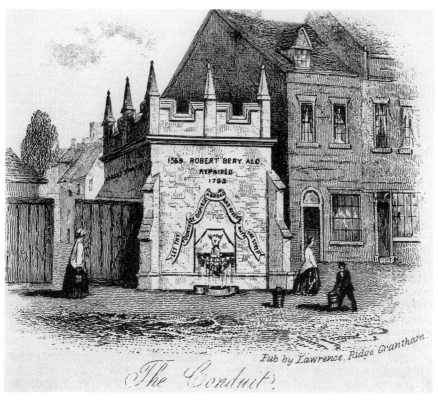

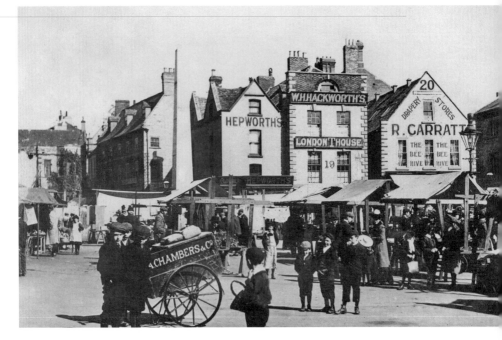

Chambers handcart stands in the centre of the Market Place during a Saturday market, sometime in 1905. The three youngsters standing close by are probably some of the firm's errand boys. Chambers was a large concern in the town, as will be seen in further photographs (on pages 68 and 78). The company had been located in several buildings close by but at this time was split between two locations, one on the corner of Butchers Row and High Street and the other, smaller premises between the Royal Oak and the Chequers public houses in the Market Place.

6

THE HIGH STREET

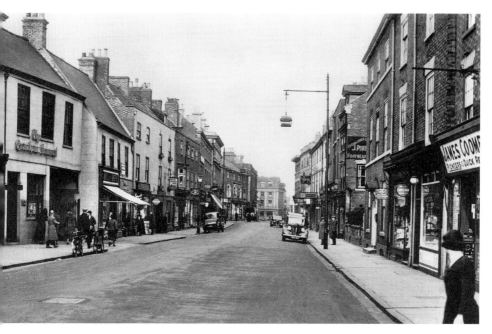

In a few short years after this postcard was published in the late 1940s, much of what can be seen disappeared, as the town planners of the 1950s ruthlessly stripped the High Street of many old buildings in a bid to modernise the town after the war. Soon the ancient building occupied by the *Grantham Journal* that was once the Mail Hotel would be no more. The White Hart Hotel, two or three doors along, did last until the 1980s, but over the road the Red Lion closed in the early 1960s.

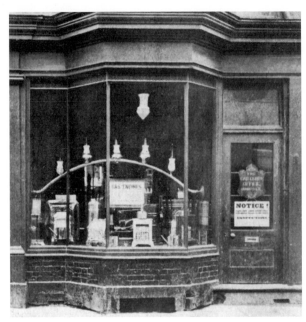

Until the late 1890s, the offices of the Grantham Gas Company had been at No. 15 Finkin Street, but by the turn of the century they had moved to the more prominent position of No. 31 High Street. The gas works themselves were up Gas Works Lane, off Harlaxton Road.

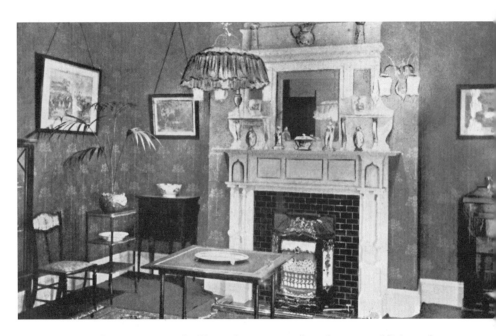

For many years, the gas company had been the main supplier of power and light to the town, but by the early 1900s they were coming under increasing pressure from the Grantham Electricity Works, which opened in 1903. By 1906, they felt obliged to launch an advertising campaign, part of which was this gas exhibition captured on a card by local photographer Henry Wykes.

This is the chap upon whose shoulders rested the future of the gas company's fortunes during this time of relentless competition. Robert George Shadbolt was appointed engineer, manager and secretary to the company in 1895. He was vice president of the Institution of Gas Engineers. He remained in the job until the 1920s, at which point he was succeeded by his son Ernest.

It was not only the gas company that would have been concerned about the competition from this new means of power. There were many small businesses in the town supplying a service connected to gas production. Many plumbers had also taken on the role of gas fitters, one such tradesman was Samuel Keys, whose business premises were on Commercial Road when he sent this bill to the Grantham Scientific Society in 1891.

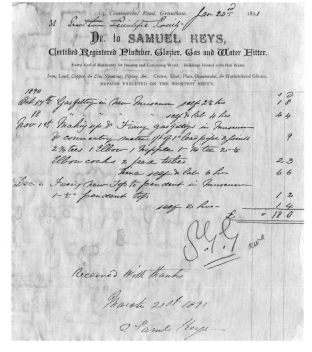

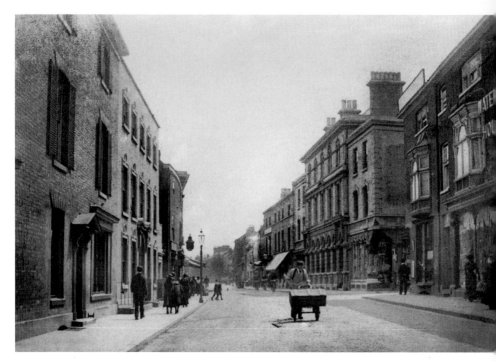

This view of the High Street in 1897 is rarer than most, inasmuch as the unknown photographer has chosen a south-facing view – rather than the one favoured by most from this junction – that takes in the George Hotel. A lone workman crosses the road with a box on wheels containing the tools of his trade as he moves to his next job. On the corner of Guildhall Street is Snell's draper's shop, one of a long line of drapers to do business from the premises since the bank buildings were erected in the late 1860s. It later became the home of Appleby, Hastings & Fosters outfitters before being taken over by Barclays bank and finally a pub, Goose at the Bank. The building on the extreme left at this time was the home of W. Garton, whose coal offices were next door. In the early 1900s, the building was converted into a shop and it became the second home of outfitters Dixon & Parker, who also had a shop in Butchers Row.

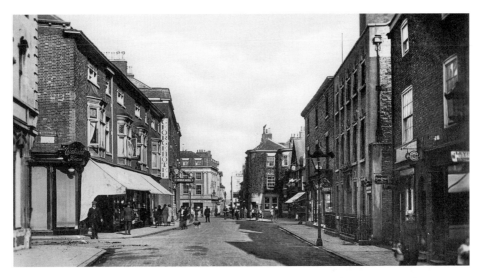

The view favoured by most photographers when standing on the High Street at the junction with Guildhall Street. Over on the right of the image, behind the lamp post, the old home of W. Garton has since been converted into a shop, but his offices are still going strong in this card from the early 1920s. The petrol pump belonging to Whipple's garage stands on the edge of the pavement behind the horse and cart.

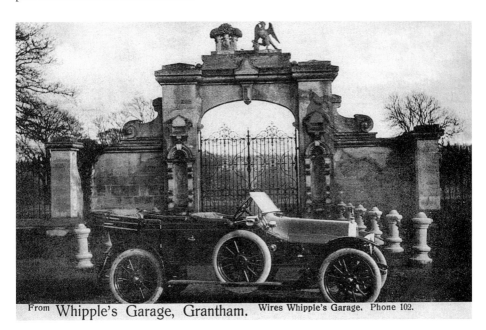

From **Whipple's Garage, Grantham.** Wires Whipple's Garage. Phone 102.

During the early years of the 1900s, there was fierce competition between local garages for the patronage of what was still a select few who could afford the new mode of transport. Whipple's garage was at the forefront when it came to advertising their products for sale. This view of one of their cars outside Harlaxton Manor gates was posted in 1915. In the early 1920s, the company left High Street and moved down Watergate, where they had previously had a department store until it was destroyed by fire during the First World War.

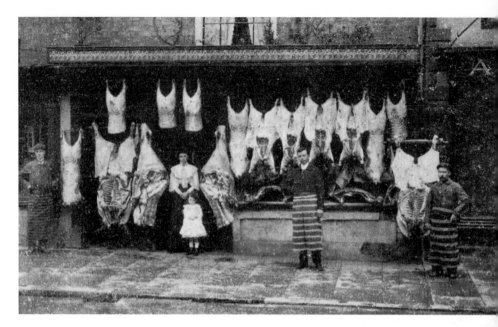

Above The Wilkinson family had
run this butchers' shop at No. 66
High Street since the mid-1800s.
By the first decade of the twentieth
century, it was the turn of William
Frederick Wilkinson to take charge
of the business. Here we see him
with his wife and child outside the
shop, posing for a photograph once
he and his staff have displayed their
wares for sale.

Right Chambers on the corner of
Butchers Row at No. 67 High Street,
next door to Wilkinson's butchers.
This postcard dates from around
1910 and includes a view of their
other shop in the Market Place at
No. 26. The latter was to close when
their new, larger premises were built
on High Street in 1911. The firm
of Arthur Chambers had made
its name selling woollen blankets
made from the sheep in Syston Park,
but by this time they were listed in
local directories as 'silk merchants,
ladies & children's outfitters, general
drapers, milliners and dress and
costume manufacturers'.

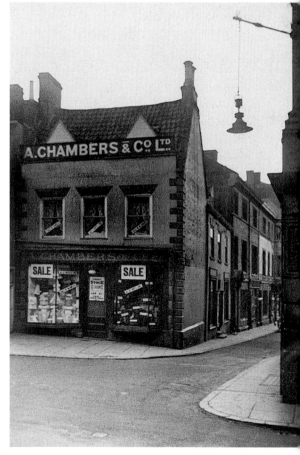

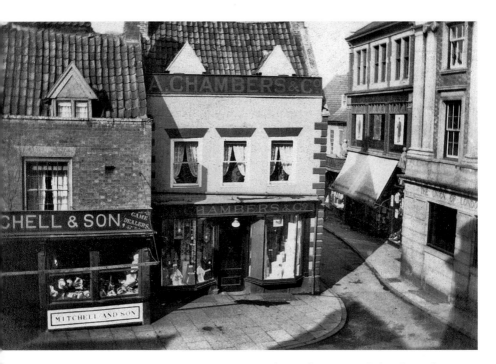

Above A later view of Chambers, showing part of the other side of Butchers Row. Dixon & Parkers gentlemen's outfitters store has the shop blind down, protecting their goods from the sun while advertising their wares from the windows above. The butchers' shop next door is now occupied by Mitchell & Son, who took over the business from Wilkinson in 1915.

DIXON & PARKER,

Merchant Tailors,

❖ ❖ ❖

B EG to call your attention to their large and High-class Stock of New Woollens for the approaching Season.

All the Cloths have been selected with great care and keen judgment, and can be confidently **Recommended** for **Hard Wear.**

The constantly increasing number of our Customers is the best proof we have that **Our Patrons appreciate a Smart Fit, Good Value, and a Moderate Charge.**

We would again contradict the erroneous impression (and which impression is foisted by our competitors), that our goods are made away from Grantham. Every order entrusted to us for **Bespoke Tailoring is cut on the Premises** by a fully-qualified practical cutter, **and Made in Grantham** by a competent Staff of efficient Workmen, the Standard Rate of Wages being paid for each Garment.

Patterns forwarded upon application ; or Gentlemen can be waited upon at their own residences, upon receipt of letter or post card to—

22 & 23, Market Place,

[55]

⏴ GRANTHAM.

Left An advert placed in a local directory by Dixon & Parker in 1901. It would seem that all the problems we see today in the garment industry are not necessarily such a modern phenomenon; the company are making a strong point that not only are their clothes made locally in Grantham, but despite evil rumours put about by the competition, their workforce is paid the standard rate for their labours.

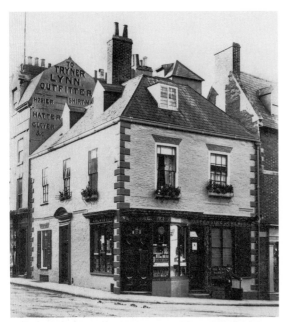

A well-known view of John Newcome's chemists' shop at No. 71 High Street, taken in the 1880s and published on a postcard by local photographer George Scothern some forty-odd years later. John took over the shop in 1851 after serving his apprenticeship with Mr Ekin, who had a chemists' shop in the Market Place. He died in 1910, leaving the business to his son, also named John. John Junior continued to run the shop until his death in 1931, and soon after the premises were demolished to make way for a clothing outlet of nationwide tailors Montague Burton.

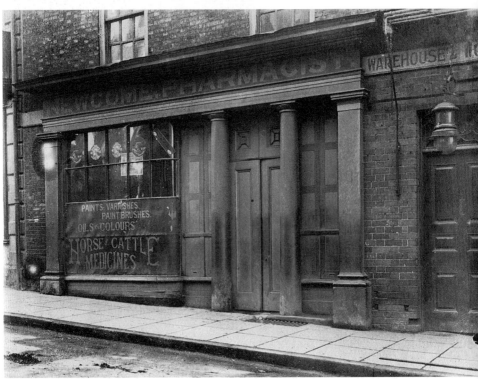

Behind the shop frontage at the top of the Market Place was Newcome's warehouse area, where animal medicines, paints and other hardware requisites could be acquired. A man in John's line of work knew that to be a successful businessman, he must cater for every offshoot remotely connected to his trade.

Right An interior view of John Newcome's shop, a rare glimpse inside a Victorian chemists' establishment. All of John's concoctions are neatly displayed on shelves. At this time, around the dawn of the twentieth century, chemists would have mostly mixed their own remedies, and John's ranged from diarrhoea mixture to corn solvent, which sold for 6*d* a bottle.

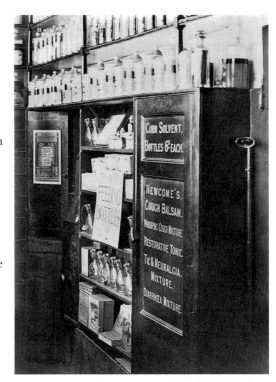

Below Another view inside the shop, this time showing his workroom, where all his miracles would be performed. I am not sure if it would pass muster in today's health and safety culture, but I bet the smells emanating from all these chemicals would make you light-headed enough not to care whether they cured you or not.

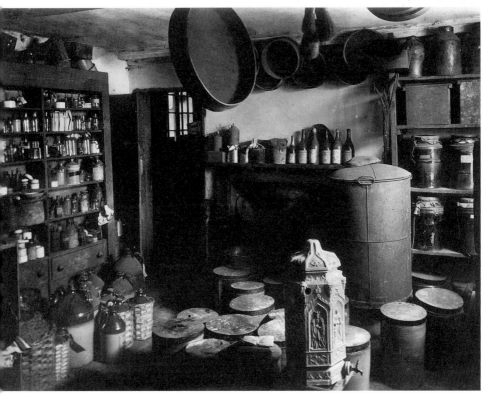

One of John's pot lids, advertising his own cherry-flavoured toothpaste. He would have had these made especially for the business, as well as printed labels for his bottles of medicines. Although the pot lid shown is quite plain, some were highly coloured with artistic designs, and are much sought after by present-day collectors.

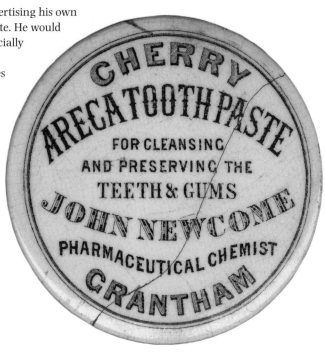

The Chemist explained to his daughter ! —
"This stuff that you see in this mortar
You can sell for a cough,
Or to take a corn off
By adding a little more water" ! !

It is unclear whether John would have found this Edwardian postcard very amusing, but it is typical of how chemists were seen by the public at large. Only the chemist and his assistants knew what went into their remedies, as at this time there was little regulation to oversee their activities.

There was plenty of competition for John, as Grantham had more than its fair share of chemists; there was even one directly over the road from his shop. This image of Coverdales dates from the late 1890s and shows that his business was at least on equal terms with John's, as far as size goes. However, as many will tell you size is not everything. Coverdale had only recently taken over the business at No. 72 High Street from William Bishop, and by 1900, the premises were occupied by John Lockhart, who is listed in the local directories as a decorative artist, painter, gilder and paperhanger.

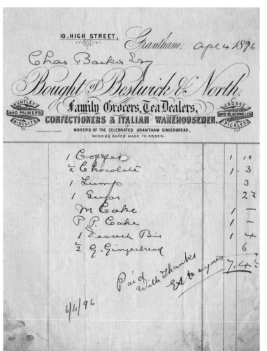

A billhead from the old firm of Bestwick & North, dated 1896. It is interesting to note that the address top left is given as No. 10 High Street. The business had been at No. 11 High Street for around two decades when the receipt was issued but the two partners were obviously unaware of the future number changes and went a little overboard with the quantity ordered from the printers decades before. A clear indication of the Victorian ethic of 'waste not want not'.

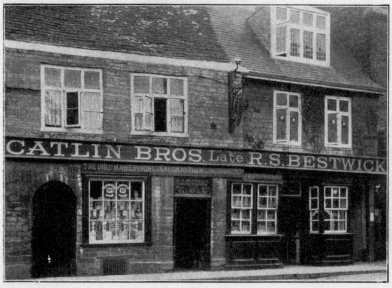

A postcard dating from the early 1900s, soon after the Catlin brothers had taken over the old grocers and confectioners' business of Bestwick & North at No. 11 High Street. The building was and still is one of the oldest in Grantham, being built in the mid-sixteenth century. Bestwick had inherited the Grantham gingerbread recipe from one of his aunts, the original inventor being a Mr Egglestone in 1740. The Catlin brothers were responsible for converting the upper floor into a café.

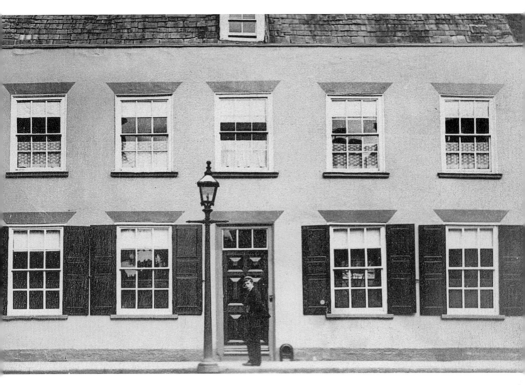

John Newcome's business premises were at No. 71 High Street, but he lived here with his wife, daughter and two sons, across the road at No. 10. This *carte de visite* by an unknown photographer dates from the 1870s and shows what an elegant home John had. The gas light immediately outside the front door would have been a bonus on dark winter nights.

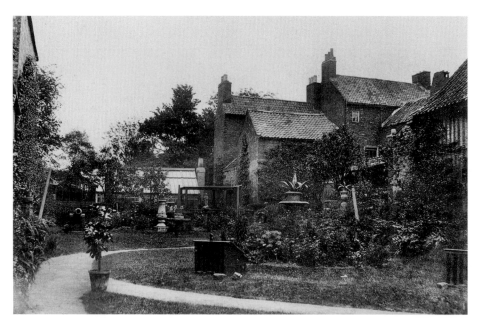

John's garden at the rear of the property was no less impressive. Backing onto Elmer Street North, there was plenty of room for garden architecture, as seen in this cabinet photograph from around the same date. It includes obelisks, urns and even the odd cannon or two. He was also a keen beekeeper, with several hives in the grounds.

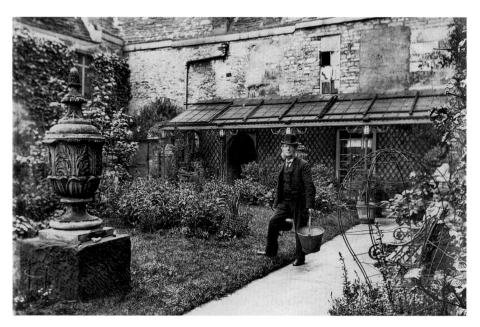

John was not averse to doing a bit of gardening and here we see the man himself with a bucket and watering can at the ready. Perhaps with a splash of imagination, one could expect that some of the plants in his garden would be grown to be used in some of his herbal remedies.

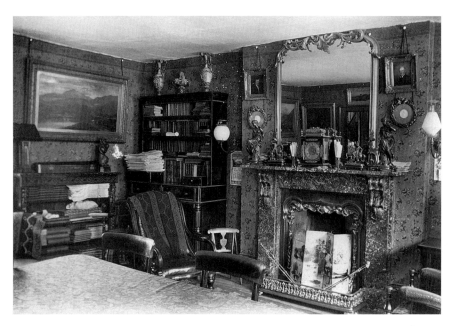

The interior of No. 10 was typical of a reasonably well-off Victorian family with fine furniture and fittings. This room shows off the standard of belongings owned by the Newcomes, which included a good collection of books and some fine ornaments adorning the shelves and mantelpiece.

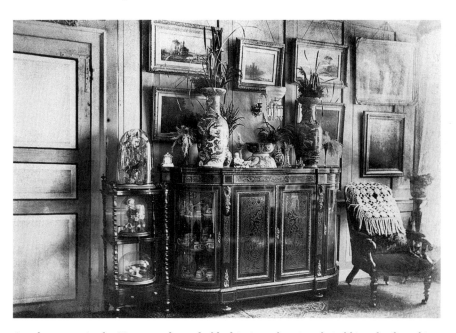

Another room in the Newcome household, this time showing their liking for fine china and paintings. The whatnot next to the china cabinet shows evidence of a popular Victorian passion: the collecting of various unfortunate birds and animals stuffed and placed under glass domes by the local taxidermist.

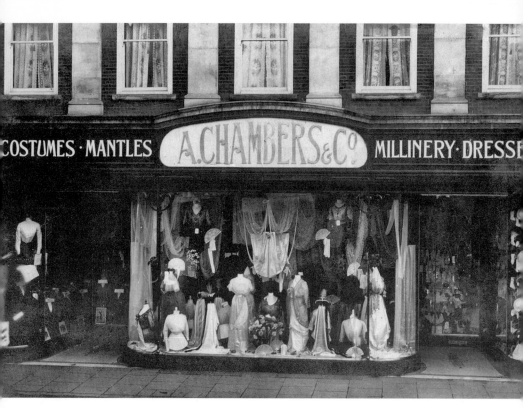

John Newcome Senior died in September 1910, leaving his chemists business to his son John Junior. He left No. 10 High Street to his daughter Florence, who had married Richard Brittain in 1894. Brittain had been an apprentice mercer with Arthur Chambers, later opening his own drapers' shop at No. 42 Watergate. By the time of Newcome's death, Arthur Chambers had also died, in 1901. The old town house was soon demolished and this purpose-built store erected in its place. The Brittain family had large apartments built over the shop, thereby continuing to live at the same address. This postcard of the new store was published soon after it opened in September 1911. Richard went on to become the town mayor in 1927.

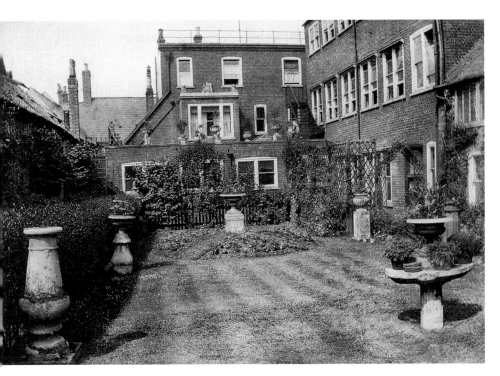

The new premises still had a garden at the rear, but compared with the old original layout, it was a more frugal affair. This is a view taken from Elmer Street North in 1917. The back of the shop is still recognisable today, only now the garden area is laid out as a car park.

A billhead from the company, dated 1927, showing Brittain's two shops at Nos 10 and 67 High Street. No. 67, on the left of the heading, was to undergo a programme of modernisation in 1928, having a complete new frontage installed, which included larger shop windows and a small corner showcase, which although now long gone, can still be noted by the overhang of the upper floor on the corner of the property. No. 67 High Street changed hands in the 1970s and No. 10 closed its doors for the last time in 1982.

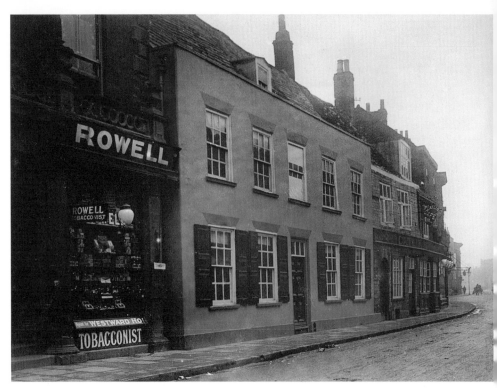

Above On the north side of No. 10 was the tobacconists'
shop of William Rowell. He was secretary of the
Exchange Hall Company, and his shop was actually
in the frontage of the building. He opened this
shop in around 1900, and nine years later
acquired a second outlet, taking the shop of
Ablewhite's, another tobacconist at No. 14
High Street. This view dates from the early
1900s, soon after William began trading.

Right A photograph of William Rowell,
dating from 1909, when he was elected
to a seat on the town council. He came to
Grantham in 1877 as an assistant to Joseph
Lord, a Grantham grocer, on the corner of
Guildhall Street and High Street. He became a
partner in the business until later branching out on
his own as a tobacconist when Lords changed hands.

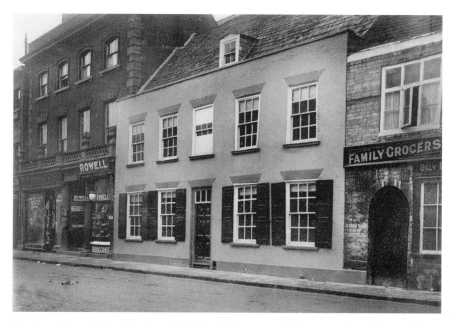

Another view of Rowell's shop, this time looking north from outside John Newcome's residence. Next door to William's tobacconists on the extreme left and sharing the frontage of the Exchange Hall is another tradesman, called Chambers. This shop was owned by John Chambers, also a draper, but according to local directories, the establishment was also a carpet warehouse.

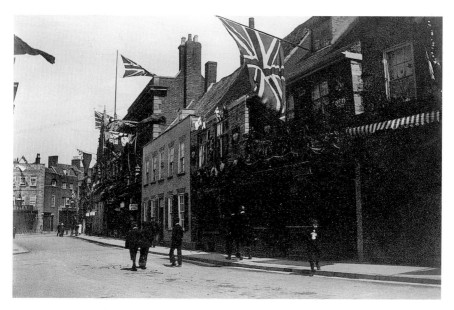

Dated 1902, this scene shows the decorations in this part of town for the coronation of Edward VII. There are plenty of flags and shields on the walls but very little else; it may be just the beginning of the decorating task, as there is a distinct lack of the paper lanterns that are seen in abundance elsewhere on other thoroughfares.

Right This old house next to the Angel and Royal was one of the oldest buildings in town when it was demolished in 1897 to make way for a new branch of Boots the chemists. Originally the home of the Seckers family, it had a panel in the main room bearing the date of 1611.

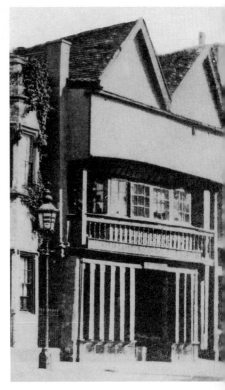

Below Taken from an upstairs window in John Newcome's chemists' shop in 1897, this photograph shows the beginning of the end for the old house. Over the years it had been put to a variety of uses: shortly before demolition, it had been the premises of Hoskins & Sons, boot and shoemakers.

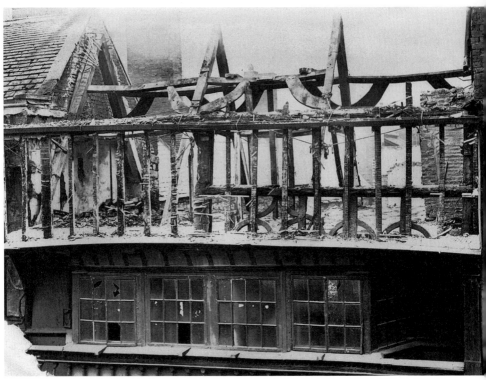

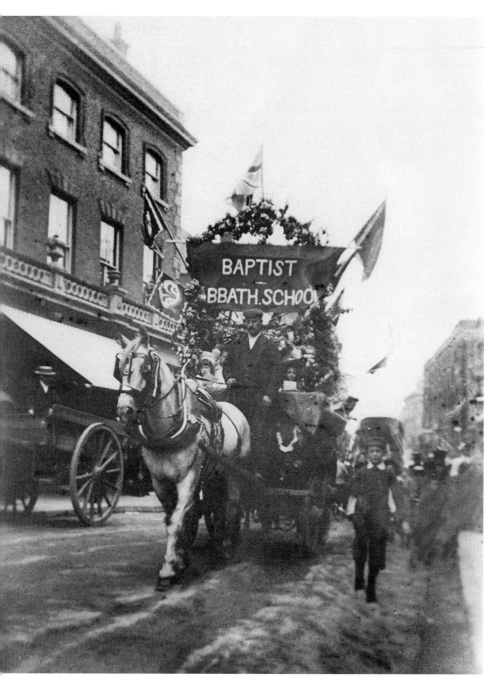

The Baptist Sabbath School float passes the Exchange Hall in a parade which sadly I have been unable to identify with any degree of certainty. There is a distinct lack of bunting on any of the buildings, so it is unlikely to be part of any type of civic occasion. It could be part of the May Day parade of 1899 or 1900, or even part of the annual Treat, when together with other schools, the children paraded to the Market Place, where they would all join in song. The school was thriving at the turn of the century, with 150 pupils and twenty-two officers and teachers.

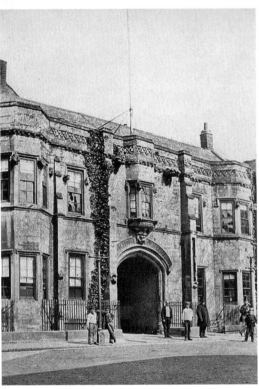

Above Once the float has passed the photographer, he or she has taken another snap of the rear of the cart outside the Angel and Royal. This view gives us a chance to date the images quite accurately. Since the 1870s, No. 1 High Street had been the home of Samuel Dawson's drapers' shop. Before D.A. Sharpley took over the business it was run from 1899 to 1900 by Walter Game, and here we see his name over the premises on the left of the image.

Left Frederick Fisher was Grantham's first photographer, opening for business on the High Street during the 1850s. This self-published *carte de visite* of the Angel and Royal dates from the late 1860s and must be one of the earliest photographic images of the establishment.

7

VINE STREET, SWINEGATE, WATERGATE AND MANTHORPE ROAD AREA

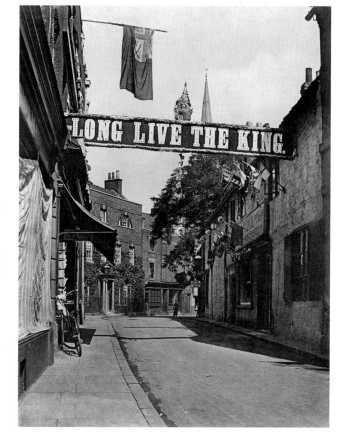

'Long live the King' states the hoarding spanning Vine Street as part of the town's decorations for the coronation of Edward VII in 1902. A bicycle leans against the shop front of Thomas Palmer's stationers and printers' shop, with the fine façade of Vine House behind the sunshade. On the right, Adcock's butchers' shop displays an abundance of flags for the occasion.

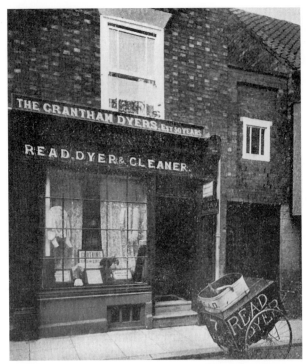

In the early twentieth century, Vine Street was a busy commercial area with a grocers, stationers, milliners, a cabinet maker, butcher, boot maker and hairdresser, to name but a few. You could also have your dyeing and cleaning done here at William Read's shop. He came to Grantham in the 1860s and opened up shop at No. 7. When this photograph was taken in around 1910, the firm's machinery was situated behind the shop and could be accessed through the side door on the right.

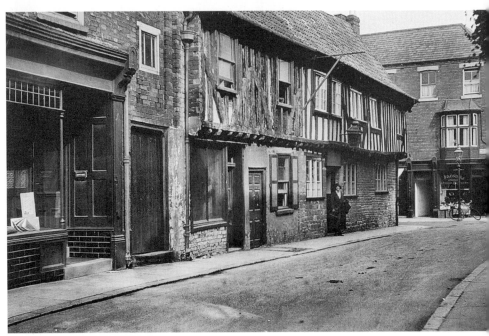

By the time this postcard was published in 1934, Reads had expanded; in the 1920s the company took over the premises of Herbert Bell, undertaker and cabinetmaker, next door at No. 6. At this point, much of the machinery was moved to the cellars. A lady stands in the doorway of the Blue Pig and across the road in Swinegate is the fruiterer's shop of John Ernest Saunders.

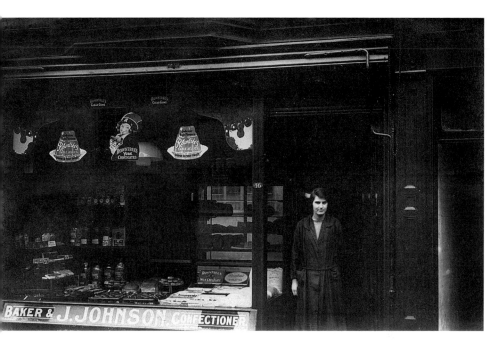

Next door to Saunders in Swinegate at No. 46 was John Johnson's bakers and confectioners' shop. The business had moved from Dysart Road in the late 1800s and at first was situated lower down Swinegate at No. 29, but by the early 1900s the business had moved here opposite the Blue Pig public house. This postcard view was published in the 1920s.

A billhead from Johnson's bakers dated 1899, when the business was still at No. 29 Swinegate. It shows that the firm were not just in the business of baking bread; they also supplied a variety of cereals, such as maize, bran, wheat, oats, etc. The smell of freshly baked bread has long ceased to emanate from the rear of No. 46; at the time of writing it is the home of one of Grantham's antique shops.

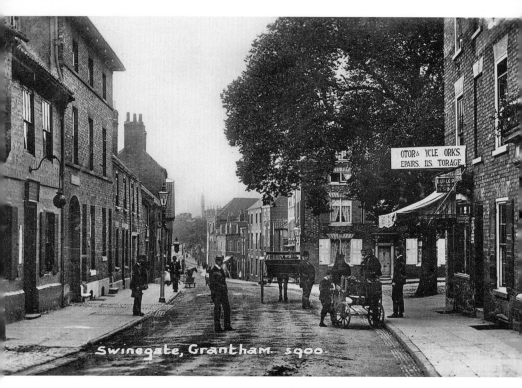

Swinegate, Grantham. 5900.

Posted to Devonshire in 1916, this postcard of Swinegate shows a busy street scene on what some believe to be the original main road through the town. Both the Market Cross and the old Apple Cross once stood nearby. The Rose and Crown public house can be seen on the extreme left, while over on the right is the motor garage of Burton & Co. Originally gas fitters and bell hangers, they were one of many firms hoping to take advantage of the new motor age.

A gentleman proudly sits in his motorcar outside Burton's garage sometime in the 1920s. Burton's were one of the firms to succeed in the local garage business, becoming the town's agent for Morris cars and renaming their premises 'Morris House'. They closed at the end of the 1960s. The premises were taken over by SHS car hire, then Temple Saunders, another motor car retailer. Several other commercial enterprises followed and at the time of writing the property is a hair salon.

A little-changed view of Church Trees from just before the First World War. The iron railings are missing now, being replaced by a low stone wall. Middle right of the view are Hurst's Almshouses, seen through the trees, which have been supplanted by a stand of silver birches, seen in the previous image. The dormer window in the roof of the house on the left has gone, being replaced by a simple skylight.

Left A *carte de visite* of the parish church by Joseph Priest, dating from the mid-1880s. At this time, you could still get a clear image of the church from this aspect before the trees made this particular scene impossible to capture on camera.

Below On the other side of Swinegate, almost opposite the church, is this old house at No. 4. The image dates from the 1860s, when it was occupied by Mary and Catherine Sacke. The two sisters were milliners and it is nice to think that this is one of them standing outside the property. The building has seen much alteration over the years, with windows and doors being changed to suit various inhabitants; however, on close inspection, part of the step to the front door can still be seen where wall meets pavement.

In this photograph, taken in the mid-1890s, Grantham's high-tech road-sweeping equipment enters the top of Watergate. The one-horsepower contraption has a large roller brush to the rear, with the driver carrying a smaller brush to collect any small bits of residue missed by the main machine. What seems to be missing is any sort of shovel to cater for the horse manure, which must have been plentiful in the towns Victorian streets.

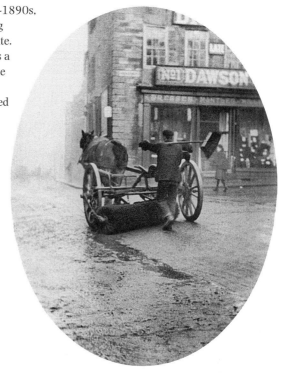

Men of the Lincolnshire Militia march up Watergate, probably returning to barracks after spending time training in the grounds of Belton Park. The photographer has captured this late Victorian scene from a window above Warren's tailors, who had the premises of Nos 73 and 74 High Street. Warren had moved from George Street to this more prestigious location in 1897.

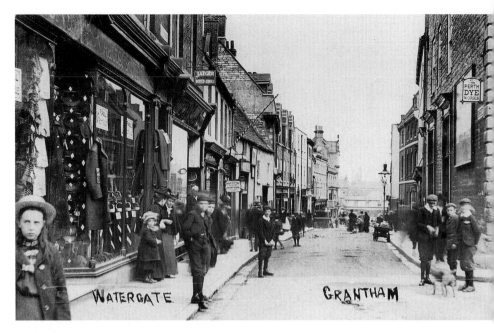

On this occasion the photographer stands outside Warren's shop to capture this busy scene of Watergate in 1905. A shopper could buy almost all of their everyday requirements from businesses in Watergate without having to venture any further south into Grantham.

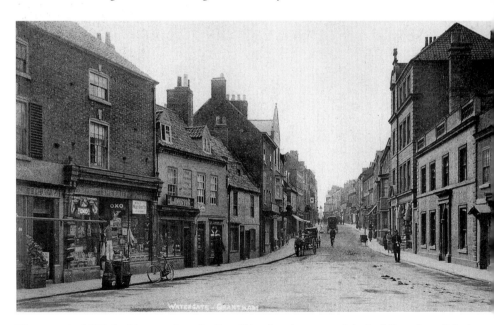

Watergate in 1908, looking south at the East Side, showing most of the buildings demolished in the 1950s. It was a wonderful selection of shopfronts, all with their own architectural individuality. The nearest shop on the left was No. 26, owned by John Simpson, a seedsman and fruiterer. Next door, at No. 27, was the grocers shop of Edward Sherriff, who had recently moved from North Street; then Lewis' butchers and William Lawson's sweet shop.

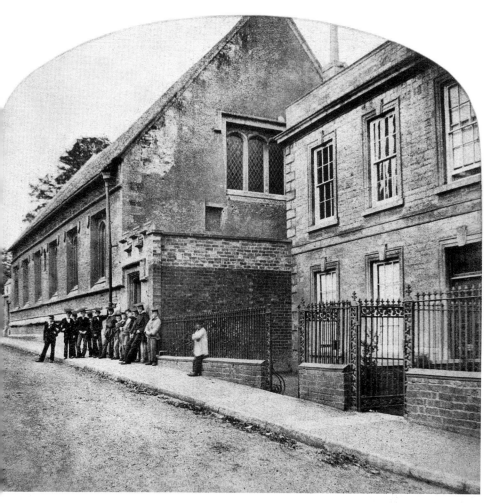

The old building of the King Edward VI Grammar School is located in Church Street, originally named Alms Lane. This card dates from the 1860s and shows a group of boys standing outside the sixteenth-century building. School uniform does not seem to be a requisite at this time, but several of the lads are wearing mortar boards. Richard Beasley was the headmaster at this time and his salary was the princely sum of £250 per year.

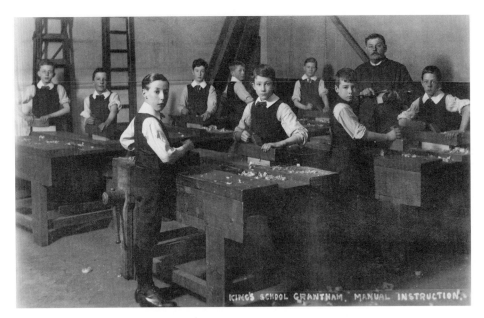

One tends to think of the boys of the grammar school concentrating on their academic studies, but here we see a class participating in 'manual studies' (woodwork to you and me). Note that most are suitably dressed for the occasion, in bow ties and knickerbockers.

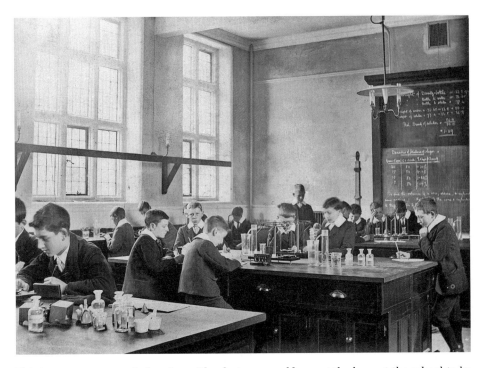

This image seems more in keeping with what one would expect the boys at the school to be studying. A group of lads are shown in the science lab, part of the new buildings erected in 1904 on the site of the old British School.

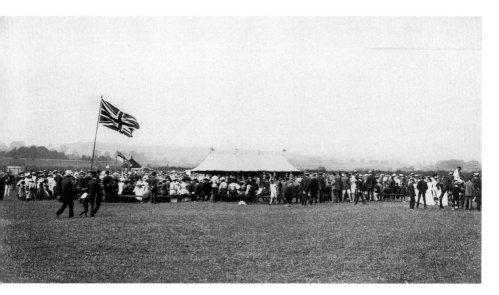

All work and no play makes Jack a dull boy, so they say, but this is certainly not the case with the pupils of the Kings School. The 1905 school sports day on 6 July shows pupils and parents enjoying what looks like a fine summer's day on the sports field up North Parade. The railway embankment can be seen over on the left.

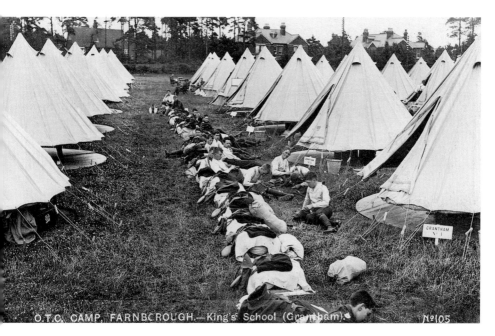

The school's cadet force had been formed in 1904, but in 1909 it became a section of the Officers' Training Corps. One year later, in 1910, they are taking part in the OTC camp at Farnborough, and these boys pose for their photograph just before kit inspection. Four short years later, many of these lads would be fighting in the First World War. The war memorial in the school gives the names of forty-five ex-pupils and staff who died in the conflict.

A cameraman stands at the junction of Park Road and Manthorpe Road in the mid-1890s and takes a photograph of Grasby Bell's butchers' cart, about to set off on his rounds from Bell's shop at No. 2 Manthorpe Road. Over on the left, at No. 11 Brook Street, is a view of the original frontage of the Five Bells public house. The property was virtually rebuilt in 1931 by local builders Arthur Eatch & Son.

Posted from Grantham in 1907, this postcard captures a typical Edwardian scene along Manthorpe Road. Once again, the photographer has gathered as many children as possible in the image to enhance the card's saleability. The building with the large gas lamp on the wall to the right of the horse and cart is the original frontage of the Wagon and Horses public house; this was altered at much the same time as the Five Bells in the 1930s. The old pub has recently been demolished to make way for a block of flats.

8

GRANTHAM IN THE FIRST WORLD WAR

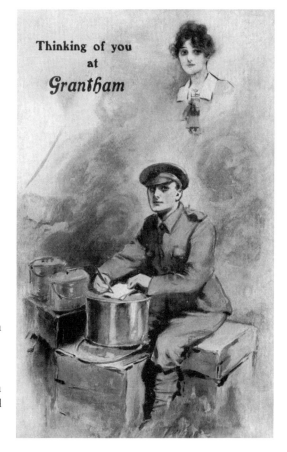

A card similar to tens of thousands sent from soldiers either stationed or carrying out their training in various towns and cities during the First World War. The cards would be published with the words 'thinking of you at', and the particular location would be added later when ordered by the local stationer. The two large training camps at Belton and Harrowby would have had more than 25,000 men when at full strength, all eager to send messages to loved ones and friends back home.

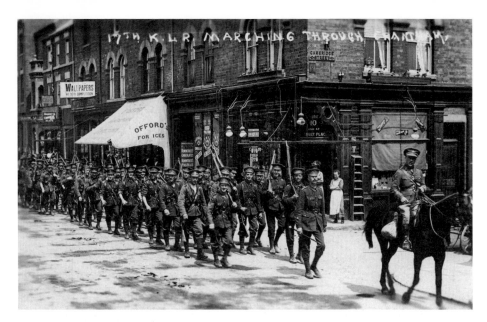

Soldiers marching through the town would have been a common sight for Grantham people during the First World War. This group are from the 17th Kings Liverpool Regiment (1st City Battalion), known as the Liverpool Pals, and they are seen here passing the top of Cambridge Street on London Road. Some of the staff of Clifford's grocers' shop stand in the store's doorway to view the proceedings.

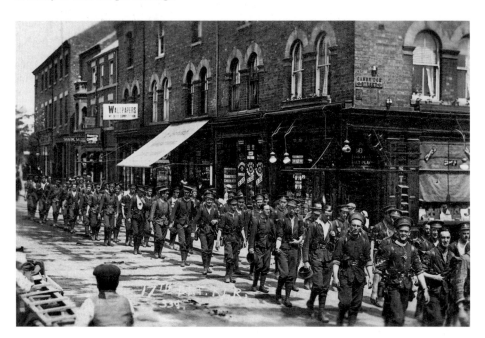

The cameraman has waited to capture the last of the marchers to pass by before packing away his equipment. The cards were published by Hiam Lang Publishers of No. 30 Grant Avenue Liverpool, the home city of the troops, where they would find a ready market for their images.

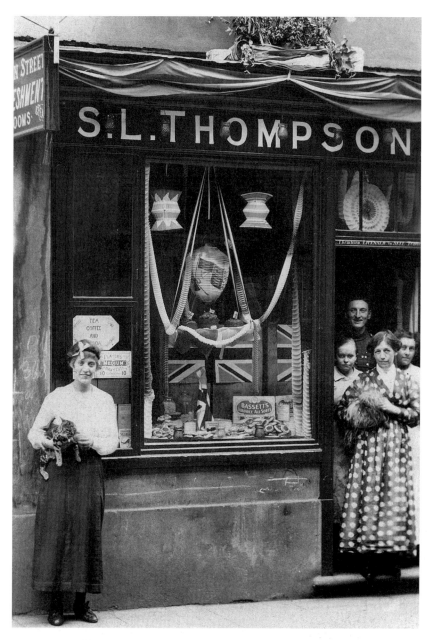

A common misconception is that as soon as the troops had any spare time, they would descend on the town in search of wine, women and song, not necessarily in that order. This is true of many, but there were an equal number of God-fearing men amongst the ranks, a lot of them members of Temperance organisations, which were popular at this time. There were many tea rooms in the town – like Sarah Thompson's – to cater for the latter, where they could play board games, drink tea, coffee or other soft drinks and perhaps have a quiet smoke with like-minded friends. Sarah's establishment was at No. 13 Finkin Street, on the corner of Elmer Street South. Most closed soon after the war, as their clientele left when the camps shut down.

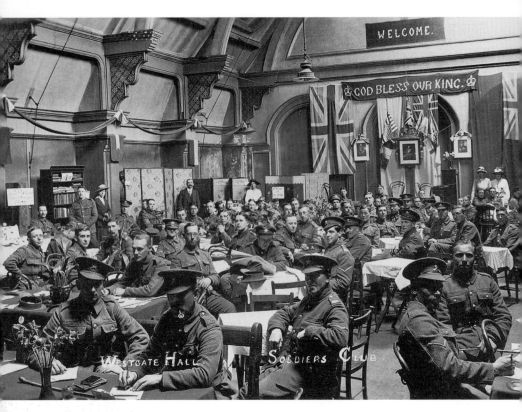

This is an example of a tea room on a much grander scale, at Westgate Hall in the Market Place. It was run by patriotic ladies of Grantham, eager to help the cause in whatever way they could; many were connected to the local churches. Most of the troops in the photograph are members of the Machine Gun Corps and several have put their headgear on for the cameraman, the cap badge proudly showing off their affiliation. The Corps was formed in October 1915 and by the end of the war had suffered over 62,000 casualties; this earned them the unenviable nickname of 'the suicide squad'.

In February 1915, this captured German gun was displayed at a military demonstration in Lincoln. The 6th (Service) Battalion Lincolnshire Regiment had brought the gun back with them to Belton Park and after being on show there, was displayed here in Grantham Market Place, guarded with bayonets fixed by soldiers of the regiment. After being viewed by many local residents, the gun was returned to Woolwich, escorted to the station by a military band.

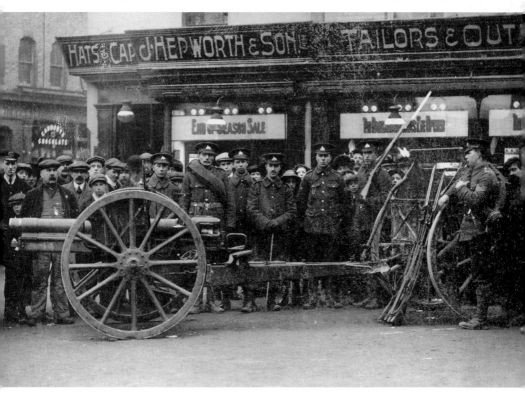

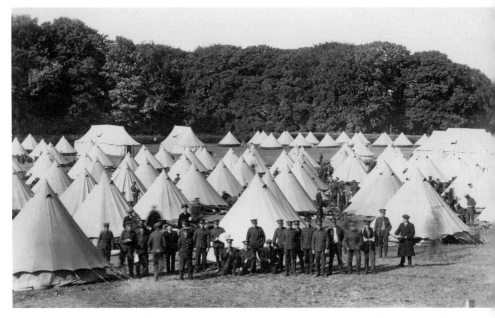

When the army camp in Belton Park was first opened early in the First World War, the soldiers were first housed under canvas in typical army tents as shown here. The postcard was published in late 1914 and shows men of the 6th Battalion, Yorkshire Regiment, 11th Northern Division settling into their new accommodation.

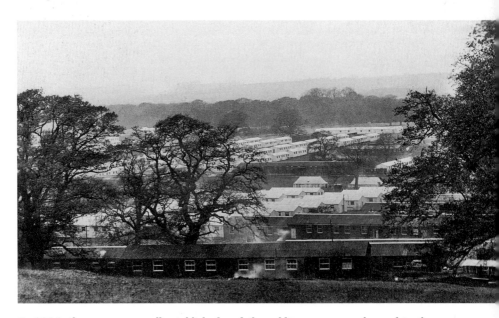

By 1915, the camp was well established and the soldiers were now housed in these more comfortable huts, mostly built by skilled joiners, but helped by others whose normal jobs had been affected by the war; these included some of Lincolnshire's coastal fishermen. This postcard sent to Manchester in May of that year gives some idea of how large the camp was at this time.

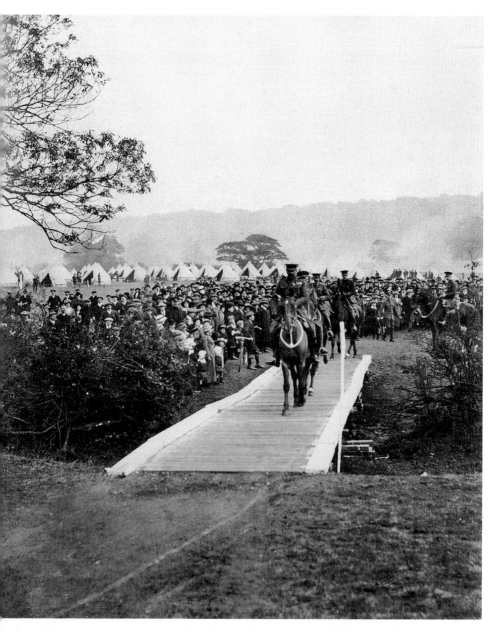

In October 1914, the camp at Belton was visited by Lord Kitchener, the Secretary of State for War. He was certainly a popular man with the local civilian community, as can be seen here as he crosses a bridge in Belton Park. Known as Kitchener of Khartoum because of his involvement in the war in the Sudan, he was lost at sea when the cruiser HMS *Hampshire* struck a German mine while taking him to Russia on a diplomatic mission for the government.

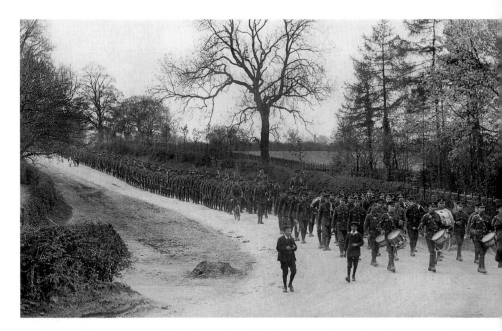

It was not only the streets of Grantham that felt the tramp of marching feet; many of the highways and byways in the vicinity of the two camps were well trodden by the men in training. This line of soldiers belonging to the Liverpool Pals are led by the regimental band and escorted by several enthusiastic children as they reach the Lion gates at the entrance to Belton Park.

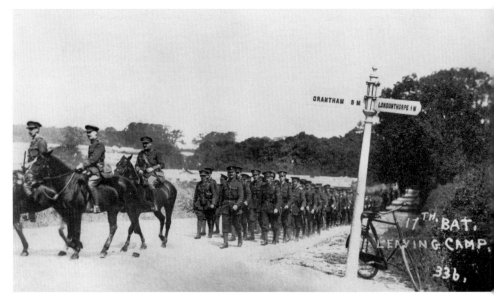

Another group from the 17th Battalion King's Liverpool Regiment leaves camp from the road known locally as Five Gates. The signpost, pointing right to Londonthorpe and left to Grantham, has a bicycle resting against the pole, probably belonging to the photographer, who sadly has failed to sign his work.

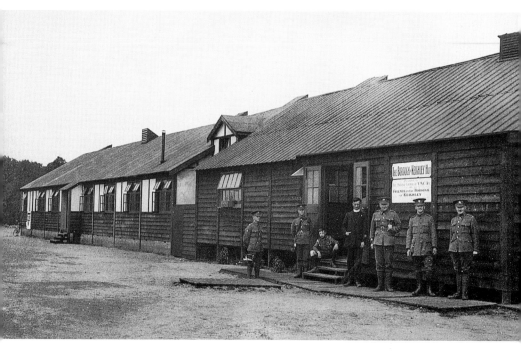

The YMCA was very active in the training camps all over the country, and several at Grantham were paid for by subscriptions from communities, where many of the troops would call home. One of the first batch of soldiers at Belton Park was the 11th Northern Division, and this hut was paid for by the people of Keighley, where many of the men would have lived and worked before becoming soldiers. The huts were a welcome respite from everyday army life and were well frequented by the troops.

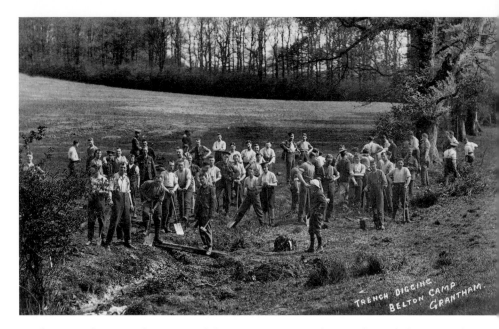

Local man Fred Simpson has captured this group practising the art of trench digging in the grounds of Belton Park. They all look relaxed and at ease as they leisurely carry out their mission, but of course there was a very serious reason behind this part of their training: their lives could very well depend on a good trench system once in the field of conflict.

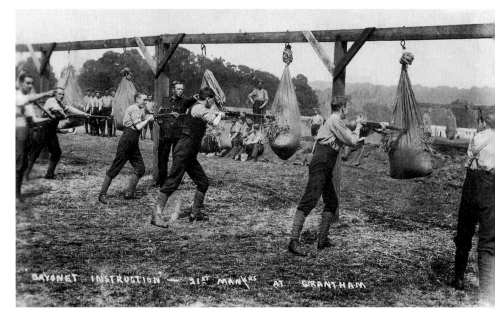

These men from the 21st Manchesters are giving the straw-filled sacks a taste of cold steel while taking bayonet instruction during their stay at Belton. They were soon to see action on the Somme and no doubt were thankful for this training in the art of hand-to-hand combat.

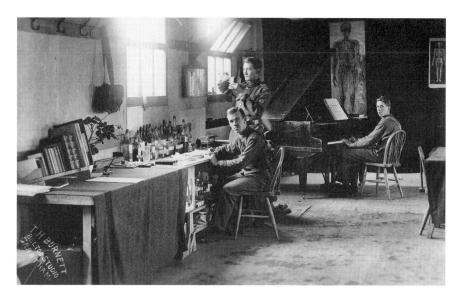

Whether caring for blistered hands from trench digging, cuts from overambitious bayonet practice or more serious ailments and injuries, the medical huts were a very necessary part of the army's infrastructure. This postcard was sent by the man sitting at the desk and he has kindly included his name and rank on the back. He was N.H.A. Parsons, Sergeant Dispenser, 3/1 North Midland Mounted Brigade, Field Ambulance Royal Army Medical Corps. His image was captured by T.H. Burnett, one of the photographers with a studio in the camp.

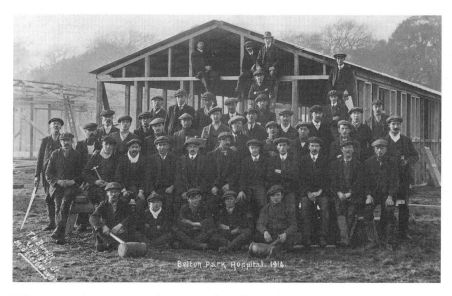

Belton camp of course also had its own military hospital, which was erected by these men proudly posing for the cameraman during its construction in 1914. When completed, the hospital could cater for any eventuality that might befall the men training at the camp, from accidental injuries to the type of illness likely to be present with such a large amount of men living in camp conditions. To this end, the infirmary had 670 beds.

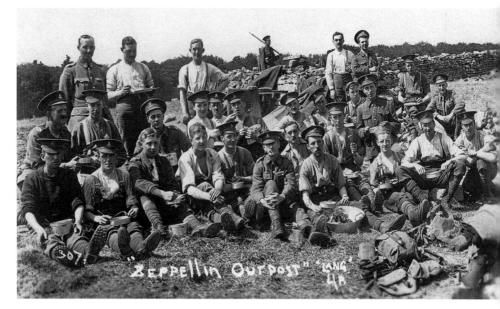

Early in the war, before the Royal Flying Corps got their measure, the threat of a Zeppelin attack was a real concern for the army and the civilian population alike. Although nothing like the Blitz in the Second World War, the damage they caused, both physically and psychologically, was a blow to the country's morale. This Zeppelin outpost, manned by men from the Liverpool Pals 30th Division, 89th Brigade, would have been one of several dotted around the camps.

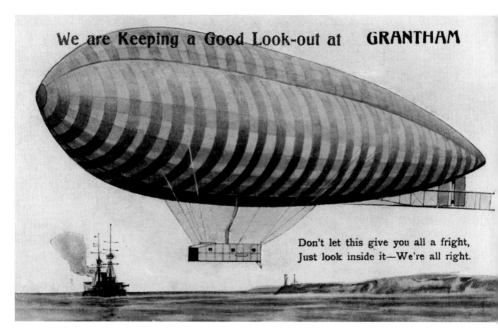

A novelty flap card that could have been sent by one of the men in the above photograph. Under the flap are twelve views of Grantham going about its business as usual, with a reassuring two-line poem making fun of a serious situation in typical British style.

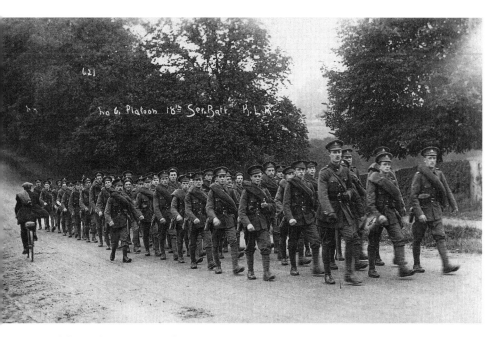

Men of the 18th Service Battalion, King's Liverpool Regiment march along the A607 on their way to the firing range on Belton Lane; it was on the right, just before the main railway line. Much of it now is part of one of the area's golf courses and apart from several grassy banks, no clues remain of its existence.

This small pamphlet would have been issued to every man before he was let loose on the firing range. It may seem a little simplistic to modern-day readers, but it should be remembered that many of the soldiers came from industrial cities such as Liverpool and Manchester, etc., and would most likely never have used a rifle before. It was compiled by Captain P. Balfour in August 1914, barely a month after the outbreak of the First World War.

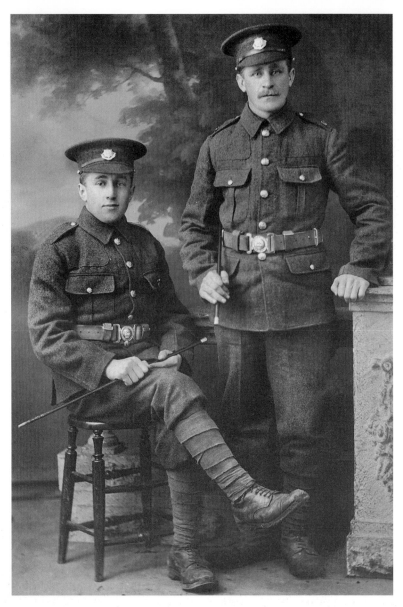

They say it's an ill wind that blows no one any good, and that is certainly true as far as local photographers were concerned during the First World War. Most of the men at the camps of Belton and Harrowby were keen to send photographs of themselves back home to family and friends. This was the case in camps all over the country, and their images were produced in the tens of thousands. The men in this photograph are from the 11th Northern Division, East Yorkshire 6th Battalion. Their likeness was captured by Simpson of Wharf Road, with his standard studio props of a stone pillar and background canvas of a country scene. Like so many other images of men who were soon to risk their lives for king and country, there is only pride, humility and a hint of amusement on their faces, and not a hint of anxiety for what the future holds.

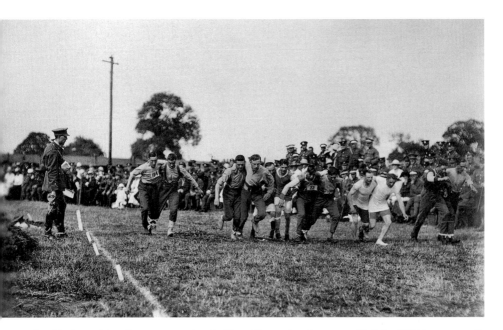

The Machine Gun Corps sports day held at Harrowby Camp on 21 July 1917 was a well-attended event. As it was a Saturday, many from the local civilian population were able to come and watch the soldiers take part in the competitions. It is hoped that the chap on the left holding a revolver in his right hand is not there to shoot any unfortunate who may break a leg during the three-legged race.

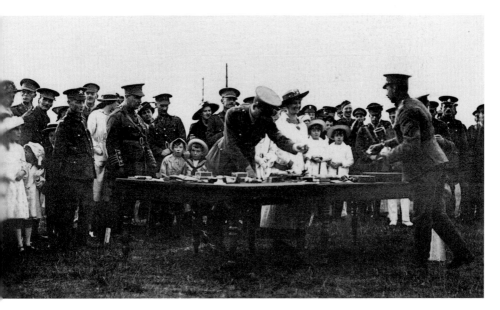

The events ranged from the standard sports day activities – such as flat races and field events – to more light-hearted competitions which included pillow fighting, tent pegging, a tug of war, a wheelbarrow race and bomb throwing. The above image shows the sports president, Colonel N.F. Jenkins and other senior officers attending the prize giving.

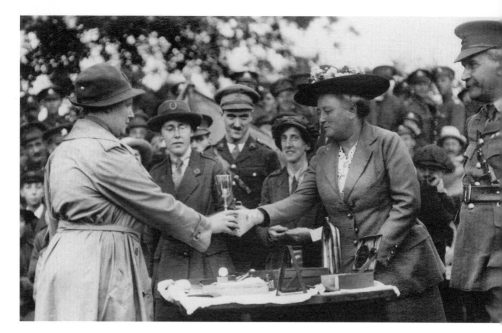

The ladies of the Women's Army Auxiliary Corps also had their sports day at the camp with many similar events. On the back of this postcard, it states that the lady receiving the cup is doing so on behalf of the winners of the relay race.

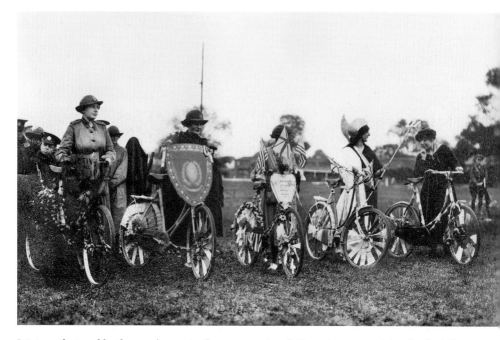

It is true that, unlike the men's events, there was no bomb-throwing competition for the ladies, but to keep things fair and on an even keel, the male soldiers did not have a decorated bicycle event in which to participate.

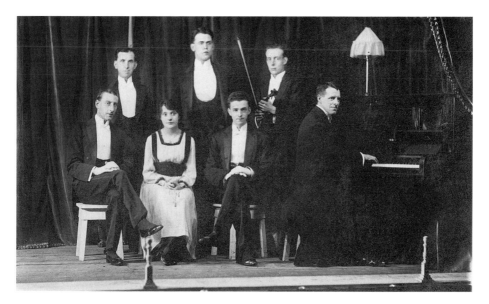

The Harrowby Concert party (Machine Gun Corps) performed at many local venues throughout the war, giving all proceeds to the war effort. They are all named on the back of the postcard, the sales of which were devoted to the St Dunstan Home for Blinded Soldiers (now Blind Veterans UK). Back row: Private G.H. Hirst, Sergeant G.H. Welch and Lance Corporal H.N. Terry. Front row: Sergeant B.L. Mead, Miss Elsie Hart, Sergeant J. Ingram and Lance Corporal J. Parker. Miss Elsie Hart was a local girl from Bridge End Road; she was the vocalist of the party and also performed independently at other fundraising events.

Harrowby Camp had its own hospital close to Cherry Orchard on the New Beacon Road and Harrowby Lane junction. This postcard of the sisters' quarters and gardens is dated 1923, when it was run by the Ministry of Pensions. For many years, this area of town was known by the locals as 'Pensions Corner'.

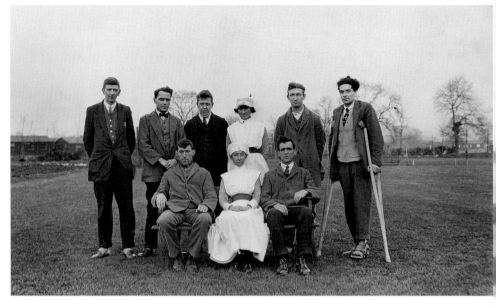

Above A group of inmates at Harrowby Camp hospital, with two of the nursing staff. The hospital was opened in 1914 and at first was run by the Royal Army Medical Corps. It later specialised in shell-shock victims and, after the war, treated ex-soldiers suffering from nervous disorders.

Sunday

E53 Mess,
Harrowby Camp,
Grantham.

My dear Mary.

I am awfully sorry I have not written you before but I have really had no time for letter writing. I am hoping to be home on leave soon & then I am coming to spend the day with you & we will have a jolly time then. of course that is if I may come. I should just love to be in Lytham now instead of this beastly

Left A letter sent from the camp in 1917 by Captain Eversley Mansfield. The letter bears the Machine Gun Corps emblem on the top left and on the right, Captain Mansfield's home from home, E53 Mess, Harrowby Camp. The letter covers three pages and in between some personal messages, he states that the camp is a beastly place; they have had nothing but rain for a week and it is very cold.

Right Brigadier General Henry Cecil de la Montague Hill commanded the Machine Gun Training Centre and, as befitting his rank, he looked for somewhere a little more upmarket to lay his head. This is an agreement between the General and Mr H.C. Moresby White for the tenancy of Harrowby House, which was close to the camp. The rent was five guineas a week. Hill Avenue is named after the general.

DATED *22nd March* 1917

MR. H. C. MORESBY WHITE

and

de la
BRIG.GENERAL H. C./M. HILL

Copy

A G R E E M E N T

for tenancy of Harrowby House

Grantham in the County of Lincoln.

R.A. White & Son
Grantham.

Below Soon after the war in 1919, Harrowby House was taken over by the Kesteven and Grantham Girls' School and at first was used as a dormitory for boarders. This image, taken soon after, with a number of the girls in the grounds, shows the southern aspect of the property with the parish church in the distance.

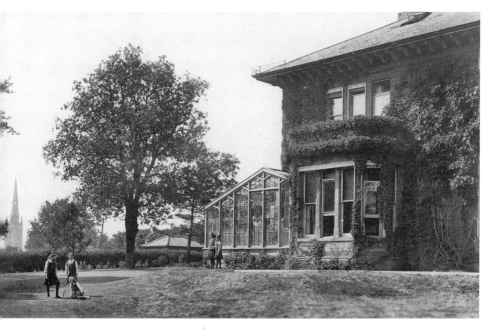

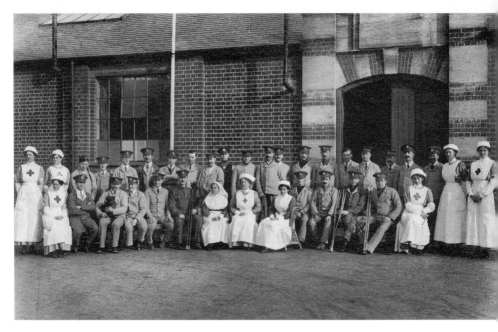

The military hospitals were not all within the camps. The old barracks on Sandon Road became a hospital caring for wounded soldiers during the conflict, and these men, with some of the nursing staff, appear on a postcard dated 1916. They wear the cap badges of several branches of the army, which includes the Lincolnshire, Royal Berkshire, West Kent, Wiltshire and Manchester regiments. There are also Seaforth Highlanders and a soldier from the Royal Irish Rifles.

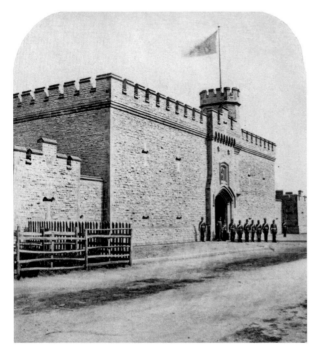

The barracks were built in the late 1850s for the Royal South Lincolnshire Militia and their emblem can be seen still residing in stone over the entrance to the building. This image dates from the 1870s and shows a group of men parading for the camera.

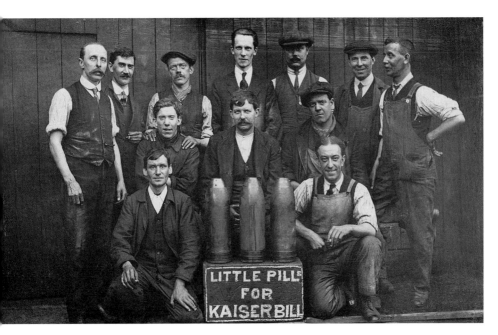

Men from the Richard Hornsby factory pose with three shells destined for use against the Germans, just three of many thousands produced by the factory during the war. These photographs of munitions workers are not rare, but it is unusual to see a group consisting of all male workers. Hundreds of women were employed in the manufacture of armaments during the hostilities and they are often seen on postcards, proud to show their patriotism and contribution to the war effort.

People showed their patriotism in many ways; this card was painted at Christmas 1914 by 23 year-old Daisy Bradley, showing her support for the cause. Daisy worked in the Great Northern railway refreshment rooms at the station and would have witnessed soldiers leaving for the front and many wounded returning home for treatment at the town's hospitals.

To our 'Little-Mother'

in memory of the pleasant times
spent in the society of herself and
her husband J·B·Wigfield Esq.
from a number of her "boys" who
gathered from all corners of the
Empire, were, by divine gift, helped
inspired and entertained by their little
mother & her husband, during their
stay in Grantham whilst training for
their part in the great world war
1914 ~ 1915 ~ 1916 ~ 1917 ~ 1918·

THE OLD
BIRD

Many local families made their homes an open house to the troops training at the two nearby camps. The Wigfields of No. 5 Gladstone Terrace were one of these families and this book was compiled by someone identifying himself only as 'the old bird' in appreciation of this selfless act. The book is full of letters, poems, little watercolours and postcards sent to the family by grateful soldiers who had been welcomed into their home. Joshua Wigfield was a manager at Garratts drapers, who had premises in Waterloo House on the High Street. His wife Lizza, the 'Little Mother' in the title, was a member of the Grantham Philharmonic Society and both were active in the Church Missionary Society.

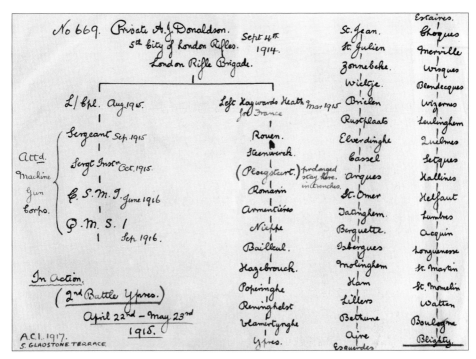

Above Private A.J. Donaldson joined the 5th London Rifle Brigade in 1914 and has set out his progress through the war in this letter to the Wigfields. It reads like a family tree, with his progression through the ranks on the left after his transfer to the Machine Gun Corps, and on the right, a list of all the places he was sent, including being in action at the Second Battle of Ypres in 1915. His journey ends in the bottom right corner where he has underlined the word 'Blighty'.

Right One of the many poems in the book sent back to Grantham, by men who enjoyed the Wigfield family's hospitality. It was written by Arthur R. Thomas of the 17th King's Liverpool Regiment, one of the many Lancashire men at Belton Park in the early days of the war.

IF one poor burdened toiler o'er life's road,
Who meets us by the way,
Goes on less conscious of his galling load,
Then life indeed does pay.

IF we can show one troubled heart the gain,
That lies alway in loss,
Why, then, we too are paid for all the pain,
Of bearing life's hard cross.

IF some despondent soul to hope is stirred,
Some sad lip made to smile,
By any act of ours, or any word,
Then, life has been worth while.

17th King's L'pool.

Arthur R. Thomas.

John Cornwell Appleton
11th/2nd Res Batt Yorkshire Regiment
Stationed at Richmond Barracks
Rugeley Camp, Cannock Chase, Staffordshire.
Volunteered for Machine Gun Corps May 1st 1916.
Arrived in Grantham May 8th 1916 and
joined Signalling Company.
Put in Signalling Stores as Instrument Repairer
September 27th 1916.

John Cornwell Appleton began the war in the 11th/2nd Reserve Battalion Yorkshire Regiment, but in 1916, he volunteered for the Machine Gun Corps and finished up in the signalling stores at Belton. John was one of the men who sent the Wigfields a short history of their army days, accompanied by a cartoon of their experiences.

The front cover of a card sent by Lieutenant Thomas Stanley Glover. He was a Canadian who came over to England with the 1st Canadian Expeditionary Force in 1914 and later joined the 3rd King's Own Yorkshire Light Infantry and Machine Gun Corps. At the bottom of the page is a hint of his sense of humour, as he states that copies of the card can be had for 1*d* per 1,000.

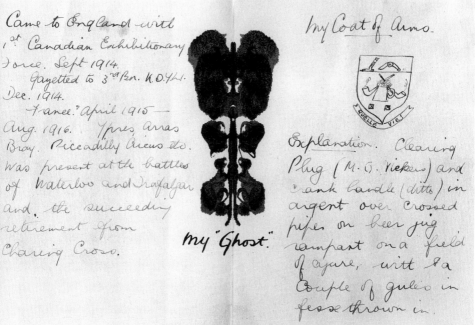

Inside the card on the left is a brief history of his time in the army, ending in tongue-in-cheek style by stating that after Piccadilly Circus he was also at the Battle of Waterloo, Trafalgar and the retirement from Charing Cross. On the right, after an image of his 'ghost' down the middle of the card, he shows us his coat of arms, mostly made up of machine gun parts, beer and baccy. If the war could have been won with imaginative humour such as this, it would have all been over by Christmas.

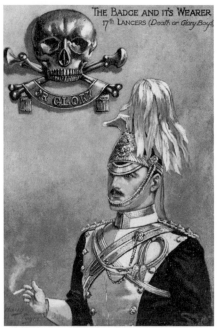

THE BADGE AND ITS WEARER
17th LANCERS (Death or Glory Boys)

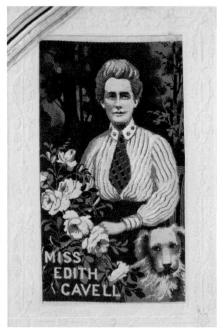

MISS EDITH CAVELL

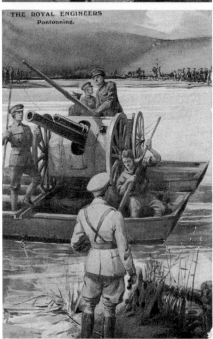

THE ROYAL ENGINEERS
Pontooning.

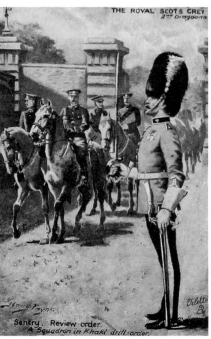

THE ROYAL SCOTS GREY
2nd Dragoons

Sentry. Review order.
A Squadron in Khaki drill order.

There are many pages in the book covered in postcards sent to the Wigfields from all parts of the conflict, many showing war damage in France and Belgium. These four are on a more patriotic theme; three show regiments of the British Army, and one is a silk card of Nurse Edith Cavell. She was shot by the Germans for assisting British soldiers crossing enemy lines, and the Allied propaganda machine seized on this as a means to show the British that they were fighting for a just cause.

Some of the poetry in the book is very good, some of it not as good, but as long as it comes from the heart, all is forgiven. This one is by Captain H. Macleod of the Machine Gun Corps, and in it he tries to express his gratitude to the Wigfields for their hospitality in his time of need. He, like many others, makes reference to the steps at No. 5. Gladstone Terrace; it is built on a steep incline and there is a fine flight of steps leading up to the front door.

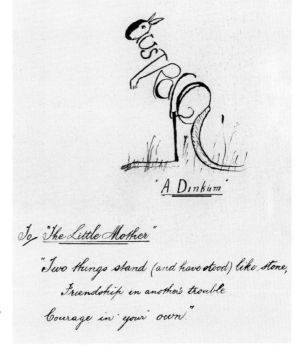

Every golden ray was hiding
In November's sombre cloak
Grey and misty scud was riding
Oer the almost leafless oak
Scarce a blossom decked earth's bosom
Scarce a wild bird tried to sing
Sad winds sighing — stray rooks flying
Heralded the Winter King
But the power of Sun and Flower
Were no needful joys for me.
As I stood — a welcome comer
On the steps of —— No 5

Never can your kind hearts reckon
The elixir-drops ye poured
When ye roused a hand to beckon
Me, a stranger, to your board
Let me thank ye, let me rank ye,
'Mid the kindest ones to me;
For ye gave me what I prayed for
Sympathy — m — No 5

H Macleod Capt. M. G. C. 30-4-19

'A Dinkum'

To "The Little Mother"

"Two things stand (and have stood) like stone,
Friendship in another's trouble
Courage in your own."

A sketch by Australian Lieutenant E.L. Bowden of the 8th Australian Machine Gun Company illustrates what a dinkum is, cleverly made up of the letters spelling Australia. Under the sketch he sends the 'Little Mother'; a short but prophetic verse which, it is hoped, would give her some comfort in the future months and years.

For all their Christian charity and generosity shown towards the soldiers, the Wigfields were not to be spared their own personal tragedy. Their son, Second Lieutenant Joshua Biram Crossley Wigfield of the Royal Engineers, is buried here in the Doingt Communal Cemetery Extension on the outskirts of Peronne in France. Joshua was wounded on 20 September 1918 and died in hospital the next day. He was 21 years of age and the Wigfields' only child.

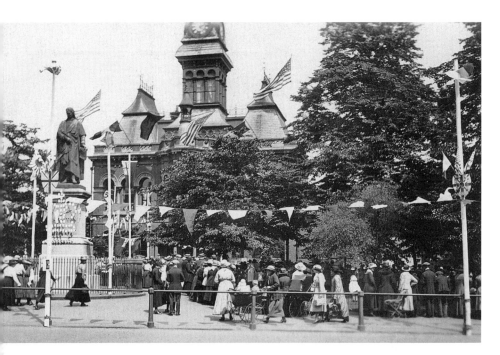

In July 1919, Grantham – like most other towns throughout the country – marked the end of the First World War by decorating the streets and thoroughfares of the town for the peace celebrations. This group on St Peter's Hill are waiting for the parade to march past the Guildhall.

A group of children sit beside the fountain in Wyndham Park sometime in the early 1930s. One wonders if they know that they are sitting in the town's memorial to the local men lost in the First World War. The park is named after William Reginald Wyndham who, at the age of 38, was killed at the First Battle of Ypres in 1914 and is buried in the Belgium cemetery at Zillebeke.

Grantham. **Borough.**

Official Programme.

OPENING of the Grantham Town War Memorial. Wyndham Park

THURSDAY, 10th JULY, 1924. at 2-20 p.m. by the DOWAGER LADY LECONFIELD.

Lyne & Son, Grantham.

The Dowager Lady Leconfield, William's mother, donated £1,000 towards the building of the park. There was already a recreation ground and public open-air swimming baths on the site, but work to convert the area to the Wyndham Park we know today began in 1922, when 400 unemployed men were given temporary work to complete the project. The park was officially opened on 10 July 1924 by the Dowager Lady Leconfield, and the official programme shown above contains the order of the proceedings, including prayers and hymns, the music being played by the Ruston & Hornsby band.

The last image in this book is the front cover of the Wigfield volume. Tooled in the leather is the word 'Remembrance', a suitable ending for the book in general and for this chapter in particular.

If you enjoyed this book, you may also be interested in ...

The Story of Boston

RICHARD GURNHAM

Founded shortly after the Conquest of 1066, Boston ᵻ
become the most successful English port outside of Lo:
of the wool trade in the thirteenth and fourteenth centu
building of St Botolph's, the largest parish church in the
the seventeenth century the town was strongly Puritan, c
inhabitants to emigrate to America to found the new city c
Massachusetts. Some of the Pilgrim Fathers were imprisone
medieval Guildhall, which survives to this day. Boston's story
right up to date, celebrating the complete history of this fabulᴄ
Lincolnshire town in a volume that will delight locals and visitᴄ

978 0 7509 5573 7

Lincolnshire Heritage Walks

DANNY WALSH

This beautifully illustrated walking guide explores the history and
heritage that make the Lincolnshire landscape so unique. Covering
everything on the routes from folklore, culture and wildlife to
archaeology, geology and architecture, it tells of the past hidden in
Lincolnshire's footpaths. By including variations on all of the featured
walks, Danny Walsh allows the reader to adapt them to suit their
abilities and tastes. With a section for kids in each chapter, walkers of
all ages are encouraged to explore and engage with the picturesque anc
endlessly fascinating county of Lincolnshire.

978 0 7524 8277 4

The A–Z of Curious Lincolnshire

STEPHEN WADE

This book is filled with hilarious and surprising examples of folklore,
eccentrics, historical and literary events, and popular culture from
days gone by, all taken from Lincolnshire's tumultuous history. There
has always been much more to Lincolnshire than farmlands and
seaside towns: this is the county that brought us Lord Tennyson (whosᴇ
brother was treated at an experimental asylum in the area), John
Wesley and, in contrast, William Marwood, the notorious hangman,
and the mythical Spring-Heeled Jack. Here, too, were found the Dam
Busters, the first tanks and the fishing fleets of Grimsby.

978 0 7524 6027 7

Visit our website and discover thousands of other History Press books.

www.thehistorypress.co.uk